my it to you

John McGreal

Matador
9 Priory Business Park
Kibworth Beauchamp
Leicestershire LE8 0RX, UK
Tel: (+44) 116 279 2299
Fax: (+44) 116 279 2277
Email: books@troubador.co.uk
Web: www.troubador.co.uk/matador

ISBN 978 1783062 249

British Library Cataloguing in Publication Data.
A catalogue record for this book is available from the British Library.

Printed and bound in the UK by Berforts Information Press Ltd.

Matador is an imprint of Troubador Publishing Ltd

MIX
Paper from
responsible sources
FSC® C021018

Dedicated to Frances

'Mark what I say, which you shall find
By every syllable, a faithful verity'.

W. Shakespeare
<u>Measure for Measure</u> (1V.3.125)

c o n t e n t s

preface

I am pleased to publish here *my it to you* in conjunction with *The Poetry of It* and *In The Way of It*. The latter contains an account of how, after an experiment in automatic writing in the late 1980's, I began regularly to write down my dreams. As the dream words sang to me across the years stirring my conscious child hood memories, they seemed to collide with those which erupted from the inner depths of unconsious psychical space, fragmenting into the smaller syllabic particles resonating on the surface of the page as they rang out.

In 2003 I attended a class on Modernism and Literature at Birkbeck College, London. On one occasion while listening to a rather flat, even reading of Samuel Beckett's *Lessness*, I was struck by the number of single syllables in the text and felt as if I had fallen through the gaps between them into another place. This disorienting but stimulating experience gave me the idea soon after of solely using such single elements in an alphabetical poetic work loosely based on Melancholy Jacques' renowned 7 Ages of Man speech in Shakespeare's *As You Like It*. At the time hearing monosyllables in Beckett conveyed me into the past at least as far back as *The Syllabary* by Joseph Brookesbank in the Seventeenth Century and simultaneously forward into a new future realm when I found myself excitingly working at an unfamiliar, deeper level of abstraction on the work *my it to you*. Since then I have read that according to Peter Hall, 'A quarter of Shakespeare's lines are monosyllables' (*The Routledge Companion to Director's Shakespeare*, ed JR Brown [Routledge 2008, p153]).

In addition to use of monosyllables, the form of *my it to you* is characterised by simple mathematical use of the No 7 and a double page, 'landscape' format.

As an artist's book *my i to you* (42cmx29.7cm) was first shown seven years ago as a new work in progress at my first Exhibition of Prints, *How Is It?*, to mark Samuel Beckett's Centenary at The Irish Cultural

Centre in Hammersmith in 2006. Now named *my it to you*, the present work is the same one set out here with a few minor changes.

In its form, the No 7 is used to make 7 between words on each line, 35 lines on each page, 14 pages per part and 7 parts in the whole work. The parts are differentiated by increasingly added (1 – 7) between the words and letters in each. You may read these as 'blanks' or 'chinks'; 'clefts' or 'cracks'; 'fissures' or 'folds'; 'gaps' or 'gashes'; 'holes' or 'kinks'; 'lacks', 'lapses' or 'pauses'; 'splits', 'slives' or 'spaces'; empty 'voids' or 'whites'... full of snow or...

Since 2006 my gratitude has grown not only for *As You Like It* by William Shakespeare but also *The House of the Seven Gables* by Nathaniel Hawthorne; *The Mystery of The Seven Vowels* by Joscelyn Godwin; *The Secret Seven* by Enid Blighton; *Seven Brides For Seven Brothers* by Stanley Donen; *Snow White & The Seven Dwarfs* by Walt Disney; *The Magnificent Seven* by John Sturges; *The Seven Lamps of Architecture* by John Ruskin; *The Seven Samurai* by Akira Kurosawa; *Seven Types of Ambiguity* by William Empson; *The Seven Year Itch* by Billy Wilder, as well as *We Are Seven* by Samuel Taylor Coleridge & William Wordsworth.

The double page 'landscape' format of *my it to you* follows that of Stephane Mallarrmé in *Un Coup de Dés*. Partly in response to Marcel Broodthaers' version of this text (*Un Coup de Dés – Image*). I had spent some time on the seminal Modernist work to make my own interpretations, *Un Coup de Dés – Espace* in 2001 and *Un Coup de Dés – Musique* in 2002 (which I hope to publish in another volume).

Today I am glad to celebrate the Centenary of *La prose du transibérien et de la Petite Jehanne de France* by Sonia Delauney and Blaise Cendrars made in 1913, as well as *Alcools* by Guillaume Apollinaire and his shaped *Calligrammes* which were published just a few years later.

June 2013

part one

my owl is erse ye r ow a lows

me wo tis else for owls are s low

the wols ows on an own a lowe d

me sow s are slowe now i will own

his owne ti s owned a won u snow

po w it is owns as owp ure slowed

red ops a wo p in owle wi sown

then erse me pows a n or i swop

he swops a swo so wos o r ows

f or else prowls in u wor ere wopp

she wro ti sno w in ows are rowed

we rowel an owce for owc u s nowed

me snowe re snows a nowe ye s tow

the swo t is wore me stwoce i stows

he wot s a worse to swots u stowed

the rowse ti wor n or owse de tow

then e tows owt a wot u town ed

we t wo towed ont i twos are nowt

so he won t owse yu towse re towned

bo towns a wob ere bow ive swob bed

she bows a w obs ire swobs ire wobb

her owne tis ore though wor a v row

we word an ow ed ire woe wi bowed

there bowe for owes a wo b u drow

here woes i swo to word s a sword

the swor ar orlds i wor k in orked

red orks are wore for ords ers ork

your olve work s on a world u lord

so lords ers oved erei vole be loved

then orl are vore ye d rove to dove s

she loves a solve so w olve the worm

hence loved en orms an ov erse voles

the rom a slove me w orms ure wolves

he w orme da rown u worn else vow

s he vows a wov ewe won e vowed

2

me w ove wa wovs u vowe did owed

the roth is orth e woves i womb s

re d oths a wone to wro ma bom

there thor i hort a thro do w orth

de mobs are wroth u throw s i lob

he wow s a yow e blo we wowed

the yeo tis obbed a y owl erse bol

so bols are blows ire lobs u s lob

me slobs u bowl er or b a bowled

me bro bowed in a blowse to b low

he bowled i bowse so bowes a b lown

the ro bowles on a bowne me bow

she robs a bor else sor b an orbs

the bros orbed in ere sorbs a rob bed

me brow u worb ere clo to br ows

so loc a browe d are col i browd

the r own u cols i cho were clow

de rowned are chow as ow ne ti brown

hence clow is owsed if ocs ure s cow

he brow sed a cow i woc are clowns

she cows me wocs to cow l i cowes

the cro w i cowls are worcs u scrow

me cowle ti hod a cowed e c rowds

the crow d e do we crows u crowl

me hod a crown i dho to r owned

ned ows a hods u s hod are dosh

the wod e crown s a doh u dhow

the dow e wods are won i dowd

we dowl u wond u dows me d owt

she d ow a downs so twod e rown

he r olfe wa drowns a drowte do lof

hence flo twa drowth i fol are f low

the f owl er owk a wolf o dwop

the wolfe ti kow e wok i f lows

he wolf s a powd ere floe wa fowls

3

 the flowk ire fo r u fro to flow

 the rof u frow or orf a fro wns

 me glow i frowst a log u f rown

 meg ogged a g lo so logs a slogs

 me slog are slo t o wong a gnow

 the gow e glow s u slog e wog

 he glowed i g owl un orgs ore rogs

 she wogs a gown u gro t o grow

 the wrong i g rown a gowns u gor

 yer erse ti gor s ure grows a growth

 we growl s an ong u rowled in owth

 her wro can ongs ure ho sho w rongs

 where g rowths ar osh if oh erse shots

 the who we how e so howes a howk

 me show a s hown u hows o howl

 the jo howls on ere jow i how led

 he jowls an owk i know i re hows

 me know s a won are lowe to mow

 we mows a w om i known u mowed

 so mown are pa me n owch or app

 red ap i n owel if apps are nowth

 the pape ti pap er ape re c aps

 his cape we pa c u pace de cap

 pam ac a scape to space we cap es

 s he scaped e page so scapes a gape

 then pak i spaced ere kap a gap es

 de pal m e paged a kapp u gaped

 for malp a palm s i palp are plap

 he palmed e pand i p arm a parp

 his erse she p awl a ped are peb

 the depp o r ipe we peine to dep

 me pen ire de pens ers are p enes

 so spen a pence de sp end a pep

 the ne p e pends ere peps ar up

 to perc a cre p i perle wi perf

 4

me p er a perms i perp u pes

the s perm it eps a per en esp

dens ept in ests a spe w i sep

tes s ets a step as est ire spet

she sept in ep or e te steps in

pet e teps a spete with etes ire tep

hi s pewl ar ased a phased ere phat

phils on a phene to p hile me phon

de phobe w e phor if ones a phoned

red s orp i p honed ere phor are phos

me phore ti phot u phra se wa phren

my ics are p hut erse phyle pic ased

mine spic icts on a p ict ure pinc

the pind ar e spics erse pine ne pein

he pines a spin e for ined u spines

the pint er e pints a pips i piped

pip ipes it u p ure pipe tis ipped

his ips are pirr e pi s i pipped

we si t o piste its ippe were sip

the spite de spi wi stipe me pit h

ted aced else pla with i n a plan

he planes u spite s a plau to plays

the place do plaur a p laud its ayed

here plene ti plew are pli m opp or

me plims i plinth else ploi d in opps

me plinths u plote wi plounce to p lop

the plum e plops a plute re p lummed

the plopped are plums i plu w here plup

her plume me pock er umed e p lumps

the police we pomp as e plump ed on

de pon re ponce so p lumes are ponds

the nop u p onced are pons ere spond

pop opped a pope to grope t he pond

the popp er e pops a pose me gropes

so porge ti p osed e popes a groped

5

we pote to t ope the prad o n oped

the stopes i stope so prau ti p raps

he topes ere p reb o preg ire prel

mi prem on its are p rep e perp

de prest e step i preve to p reps

ye prey a p rice do prim e me prill

we priced its im o preys a re primp

the prince ti preyed a p rimes i proph

he pri med a psalm i pseud o prom

the puce do psal m an up erse slup

me pulp it ulp ore pulse re p seuds

the proms ump in a psalm s u pum

they ulped a pulps as ulsed are p unt

the pup umped in a punch i p ump

red un ched u punts i quap e quip

me pups are pute to r amp an ups

de quips ure rap u pra wa r amped

my arp its ap ped i raps e quipped

he pars a par u spar i r amped

so rep in am ped a rasp i spars

me reps are rasped a spre to p er

where repp i pri do pir u r asps

he rip s a pris e scalp i schlepp

the spir o risp a spri wa s crap

de calps u scrim p e scraps i scalp

he hops o calp a sculp u s calped

the serps are posh i s hop er alped

she scr imps a shops u lus i poshed

the shrimp e shopped a s kimp i slap

mine slu were shrimps i sli p ore sul

the pils e slaps ere slut i skimp ed

here skimp s ar uls u slapped i slips

ye s lipped a slump ure spo to soup

the sop are slippe d a slump o pos

he sop s an ops er umps ar oups

me spa de tis up a stam ere stomp

so tamp as omps a stampe d u strin

he stomped i strip else spri t are trips

the spirt a stroil ore struse were st rips

for stube dat um ps u stomps i stump

where s ump in urs ere supp ere sur

me rus is aws as i were stu mped

thence sa suz a swamps e to s umps

the wap i paw erse w amp a swap

hence paws a was p i tap on apt

the pat e pawed are wasps o taps

pats emp i past as u swappe st ap

red apped i spa t if appe were tem

the met as emp t u temp o spats

me temps upt o to put i t ump

for stup i thrip do put s in ip

the tup a tempe d if its a pit

the tip it ips a thrip s i tips

he pits i tipp ere pi we re trip

me spit it s up a trips i tipped

pat ipped a stip i spit s e twerp

we pu to su for up ped are pus

their up s on us ere sup e supped

so vamp o whau p en uppe me sups

the twerps e vamped a whel p o whip

me whips a whisp i who to w homp

we wipe the whump e w ump a yap

her pay is iped a s aps are spay

she w isps e pays an iy o wipes

fo yi to y ip i spaye were yat

the tay i yap pe to yaup o yip

so yump in al p are pal ore lap

me plat is alps i lap s erse pals

t heir asp e sap a salp on aps

the spa ti pas as asps are sappe d

7

the bap i pab o so we b limp

he baps a cha to blip an ip ped

the champ e blips a p asch a chaps

mine chi ti chip s u chapped it irps

me chirp i cla to cla p an ipped

she claps a c lasp u clips u lasped

we clasps a clo fo clu twa c lipped

me clomp are c lops u clump else corp

she clomps an ompe d if umps ar opped

me porc on umped i p rac are clumps

red imps i crimp ere d amp e dep

the dip u pid is imped a c rimps

for dips are d amps a dri wa dor

he crappe d a dorp i prod o drop

the drips a dipped i sp ro wi drops

the prods are sprod an e so d ump

thei r epp i dumps a fap ur umped

me fla tis apped a flap s er umped

he flip s a gap i spag erse flump

the gamp i g ip o pig a flipped

me gasp at ip ped a gaps i gips

so spig u gasped are gippe t he pigged

we pigs ere glop u go where i pog

for gor p are prog e grep ure grip

the prig e grips ire s prig o prigs

he gripped a g rump i hap e harp

his aph a sprig s u gump ure pah

the harps at ar ped in elp a sharp

hence hel i pe l are ple to help

she helps it on as elpe d are heps

me sh eps an imp u heppe do hop

the pho to pi m opped in a poh

my imp er imps a sim p u pims

the re pin up i nip ere hop ped

the snips i s pin ippe nips u pins

me spins a snip ped e jap an aps

the jasp is aup i jau p are jawp

we ke p e pek erse kip ore klep

me kips are kli p i klop u kipped

the kop u lapp is ap ped e knap

so lapps erse pank u ler p a perl

de lip is im ped if imped are pil

pli limps a pil or a m are lump

yer am p e map else lu to lips

the ma t is umped i mas o pam

her ams a sam p if ump are spam

so pams are na p i naps ere samps

where sa m i nap u span e mumps

he naps an ap ped i spanne wi snap

ma qua qua spans a s nappe to quack

he s naps a quag ere squack e quacks

the quake do quale s o quare you qualm

the quan t erse quakes are quart a quark

he quaked a quar i quarts a re qualmed

he qu alms a quat u squark else quarks

me quave ti que whe que me wa quawk

the quern are qui w here que were quib

hen ce quilp i quests a quiche wi quilt

he quilts a qui m e quince wa quing

me quint i quir t are quinte wa quitch

the quo re quit e do quote me quop

so qum i squa re quite s ure squares

he quotes a squab ere s quared e squat

his squ were squaw s u sque to squelch

the squeege me sq uats i squi wi squib

reds ench are squint u squit ch in esq

whe squibs i squenc h are liq o loq

the req i squinc h else seq a suq

me toq in ar c are cra to squint

the rac is erse ye s quirm i squir

so car s on arcs ere scra wa cared
the ho r ace sca was arce to mer
me s care tis ern a rem are raced
re scar es a ren a serm on erd
for ner o rems an ner u car ed
the n erd is erds i rend u tern
me rent ure tre tis en t ire tren
the nerds a re ste so stern i set
where ernst a rends e rent s i nert
the sterne tis erts u stre wa t ers
my em er s on ine sert ire rest
his erst i ser erse ster are t res
he rest s i rerd a revd u rheum
de rhi ne ti rho so rhomb u hor
the rhodes i ric ore ci r are riel
red s isk a rin u rine me ris
he r inds a ro for its a risk
sir od is isked a r ode did oid
me rote to t ore was a dore roid
the dors a roist e risks are ron d
her orne wa s urg u rone we rort
me ruds a rug else gru wa g urs
de rugs are rukh i ru m ere mur
you smu the rum p in u wi nurse
me rums on urse d a rumps in usks
we rung a gurn e ru ngs ere runes
the rusk ins urst i f its are rusts
my rut er urt i s cru to ruysch
we t ru so tur i scru ye ruts
my ums e spur u purt i c rum
the tur p in urp a slurs e spurn
he spurs o stru to spurts a s truck
for ruth ust e the turps i th rust
de sturts i t ruth if usts are struth
she truths a thu r u thrusts i thrutch

10

your uce truck s on as udge wi trud

de truce was ump an udge d ar ucked

me trudge ti t rumped i trug ere sunk

the trumps at urds in umpe d o trust

the tur d usts it if urfed are trunks

me turfs are turk i t urm u wrung

so turds urt i to blurb a tur fed

the turks are bruges a s un i blurt

their suit is uit ere tui ye bruise d

for bruit is ume we burnt o b runt

ye bru fro brume to b rusk a brut

de turb ut ub be de brute do burg

the g rub er ubb a burse for ursch

he grubs a bursch erse cru wi c ur

the ruc in urst ere cur s are bursts

my urch in ude his uise ma c hurch

his crue where c rub i crue to cruel

he cruised a c rum as um e crumb

fo r ump i c rump o unks u crunk

the crup i scru so crus ure c rust

ma cruse wa crut a crusts ire cur b

he c urbs a curch ore cure wi curd

his urbe d a curse tha curds u curst

her ursed are c ures if ured are curt

the curve tis urved ere d rugs a drum

she curves it u gged o drudge re murd

we drummed in un ked o drunk an urd

the drunk s are drupe wi druse ye durst

they flurt a frug else fruit ere f rush

for ust ar um p ure fruits erse frust

me grudge will uft i gruel a g rumps

so grunts u strung e gurge wi g urts

the n urst i gurle wa hure to hurds

me hurs t in ures a lure do ruled

red ured a hurt s at ule me lured

11

red urked e mure so lurks a rule s

the pru here murk an ur p are pur

his une wa p rude to drupe rup it

he p rune san unt are prudes i prut

the pru wa pure re p runt u pruned

where purg ed a spu wi roa me purse

whence roar a sprunt i spurge do s tar

your arts are stra fo r oared ere tars

the rat s ire tra where thei re tar

their art i rat ars erse we b lur

the bier o w ar i blu wi raw

so boa wa s aw e blurs an oor

me chai wa r ood u bier i door

de b oars i fer e boors an erf

the c hairs er oors or ir an ur

the ref ered in a f reed e fur

while ruf u refs a he r i reh

hi gau r i furs a jar o hers

her eir i keir u lour e ra m

hence ma r i jars a raj o roul

he mars o ram as am med are nar

hi s arn o sram our oup ure ran

the pou t is ours u poured are roup

red our ed a quere to quee her orr

the parr is arre d an eer ere porr

the queer arr on an urr ire carred

de queer s in e we pure wa schnorr

the serr a p urred a schurr u scarred

his shi ti shirred are sir red ere skirr

he slurr it on a spa rred ure smirr

the starr i spurre d a squirr u surr

that arred a terre do tir r an urred

ye starre d in urr ere torr ar irred

so whe to wherr are worr i t arrs

me whi wa yarr a whi t o whirrs

12

the barr is ir re to barred a whir

my e berr irr e b irred a blurred

we blur an urre for ur r e burrs

the carr is urrs as arre ti ch arr

his chirr up erre do c irr us err

the curr are dorr o farr u flurr

she furre d it u to gnarr a girr

me tut i harre for irre wi g orr

the harr i herr a j arred u hirr

we hurr o kerr ere knor r are knurr

reds arr e larre wi m arre re murr

the morr is eres or eres a mhor r

den arr erse sa were sab u re bas

the sad e de sac ere cas arent acs

the sands is ank i sca t o safes

de sag e wer auch a kans e san

mi sa n its au wi sau hence saw

me saugh u saur an else wa s ay

the yas i saye t o sca me sawed

we see the scald e scale re s can

her an ce wa ca so scans i scaled

your ast a scance do scathe de scent

the scales a scend u p ence re schans

me scence ti s in a scene to schelm

the sce re scene do be me s cents

for e nes are scha when anse tis erm

ye s chanse me schemes as e wi scherm

my ewe were shewe d if ewn are schewn

so schiff ire schist else schlu b ate schlump

me schmaltz u schmee r i schmo we schmidt

the schnapps are schnoor u school is sc hood

t heir schwa wi schout a chaws ure schwarm

his sch took a schtoom else schtuck are scin

the scler ore scote whe s cops ere screigh

me scried are sc ribed ere scri to script

13

the scrip ts are scrod i scrog u scun

we secs o sc use wi scunge re ces

these sels are ses a me w ith ecs

de sects i sense ye sem p are seps

for emps on ensed a h ash ere shah

the serps are hashe d a sh alt i halts

my an t i shant are hants ure shash

me shan o haved it ore the n ash

he shaves a she d or eds u sheld

she m aves u shend as ersh i her

the sher ine shie to shield e s him

red ish i shieve f or ines e shined

the hips are mish ere shi p u shish

here shields a p ish as osh erse shines

me sho wa s hipped a sho wi shirts

the shive saw ose here soh an o ad

his ose was oals erse shoa we re hos

so shoa d are shoe wi hose we shoals

me shoes e shode do sh ore re hosed

they shoed it up as ors t is shored

her ort i shor t in ost ere horst

the shost a host i shot s u tosh

he shorts an ot h er ost ire hosts

tho horts are ho t an uld i shots

her ould are shre so shrie wi sh ould

ye sh outs e shrieked as ewd are shrewn

she shreds its ews u shrike me sh rewd

de shrif are shrill else sh rim e shrines

he shrined a sh rip ire shrive to shritch

me sh room u shrug are grush arent ugs

the sch tick i shtik a shtook u shtoom

yer uck e sh tuck i shtum u shtupp

your ush i shuns a shushe d i snush

she shut a tus h ewe huts are hust

de sib i n uts a bis ere husht

14

his sic it ics a sice wi sil
the cis e sile wa s ci to lies
reds isle tis ims a slei re m is
me sim a s mi we since an ins
ya sine do nis are sins e r in
si s inned a now o sirs i sist
me sit i ska the n its a skaff
so skan k e skaz i sked u skelm
the don i skete to sk ice me skil
tho skint i s ack ere sla wi skun
here ta wa slash in ats u s lack
ye slacked i yal if erse wa s layed
hence lays its ays u sli we r ayed
his ik are slaye w e slice to slik
miles ims an im u s mile to slims
he smiled a mild u s lime wi limes
de mile do lime yer im med an iled
so slits are sloid ere slo te do slud
me slui wa mons u smu t is uiced
we s mush e sluice yer ens a sned
dens ush e s nell are snite to snib
bens eb i nibs ure sneb are b ins
me snite tis orts u som a sn ored
she snorts e some to s mo me son
the somme wi some ye son s a mos
the sonde we s one to nose me sorn
she noes i t ones else sonse ma soy
for spades are spe tha t ecs u spalt
these specs i spece we spi wi sp eld
their ure me spece wit h e to spheres
so sphere ti s pence de spi me spiced
his ise wa spire ye s pied a sp ired
we p rise de spleen i spli to spliced
then ints else prised a spline so s plit
she splints erse where me spli de plores

15

part two

me s pose ti spre to sprew a sp right
so sp ring wa spu wi sp ule we squop
he springs a stade ye s ta were d ates
de stamm e st ance now un e st ands
she s tats a then as aye were stay ed
for stet is em med a ste m ere mest
hence stu sterks em or e ts are st ems
st eve saw er ife here storks e st ift
hi s oled erse stir a stight ire s tink
he sto me t orse to st ore de stol
her or m i stot as oled are storms
the stra v in ew are tots i n ewed
his es t are stre we strew o w rest
for stri strews ic t a rist e re st rict
me stro wa s trine no st rode wi wrests
she swe whe swi tw as ine ye s wept
we swi m as ein e s wine re wien
reds ines are n ei for it s arc wines
ya sp la w ined up i splo me sp lash
me s ploshed a squi ye s ta we squish
the shaw l i swa re wash a s tashed
he harts an ish ire wals h ere t rashed
then esh are s wished a thre to thr ash
me shu ca n oosh in ush er e trashed
we thresh a whi t o whished a th rush
my else whish t in a w hoo do whush
her ash i yas h as isht are w hoosh
shay ashed a y esh in ashe to y ush
the sha ha s hade wi ba sh ere habs
me sha b a b ashe ma bru there bish
de bashe d in ushe were ras h i brush
the brash er ush ed a shr ub ure cash
me sa c are scha whe n osh i cashed
chas its a clo so cos h erse clash ed
he coshe d an olc i cla do c loshed

his cra sh en esh ad ush a cra shed

the sha we crushed as is h a d ashed

she s hads an ushe no w ish i shades

red ished a r ush ed a fash ore shaf

my elf i shelf s else there wil l ush

me flesh e sh el fed or eshed an esh

ma flo ti dish ed a n osh ere flashed

he she lfed a flosh as elfs e f lushed

me fro were g ashe d are frosh un ish

mi frosh i s agged or us hed a gashed

the s hag ish ons ere gas h are hags

he shag s ure gu whe shi re gush ed

he hus hed a j osh ire knish u kosh

the lashe d are losh a lush e mars h

my e wa mashed u sham s a me nsch

we mushe de n osh u shon a m eshed

here pas h are sh ap ure haps ore hasp

so pla sh are plosh u plu sh ire pushed

the quas hed a s hra were shar e rash

me shel erse sash a s esh u quash

the shle p in osh ire sha wi sh lub

we sh or a rosh ure sho do sh ames

the sham ed ar arsh if am ar e rsh

she shote me sh ouse to sh ra de hors

the shra pe wi shri so sli wa s mash

me pe t an ish ire sil erse sm ashed

for she r un ersh a squa re s mersh

she squ ashed a n ush ers in a rush

me shru sla shed a slo he s l ashed

his osh i s lash e for else do slosh

the slu wa s loshed e suss e s lush

me susse d i swi to swis s are tass

here tess a set s else t asse wi sats

her ossed i thess e t ossed a t rass

my eds e star s a tsar ere tress ed

19

the tsar s ar essed a starre d or uss

he trussed el se t uss e vass ire vess

here viss are voss i was s ure wess

ye whas s a w hiss in ass erse whooss

me wiss er ass ed a wras se wi wuss

the sa s a yass u say s i bass

de bas se tis ess ere bes s ilbs on

she silbs a ble for es sed are b less

he r ossed i bosse re blis sed u sobs

so bra d e buss an us se where subs

reds asse do bra ssed a ro we b uss

the casse we ces s u ch asse to chess

me cla be c osse we classe d a crass

he scars an os se wi crosse d i cuss

then dass e deesse do d es s a diss

the dos s ire sods a d re wi dossed

me d ross a dress ed an ess o sees

t heir esse with on i fesse to f iss

the flo t is osse wi f osse de floss

we fossed a fras s i fris s u fussed

then usse d a gess o fusse d ere ghess

she gassed a glis s i g loss u gneiss

the gosse to g ra wer ossed a g rass

ye grossed a gue wi r osse do g uess

so gus s and ausse t hey osse for iss

the hesse do hauss ere jos s in iss ed

ho ss essed a huss u hisse d i jessed

de hiss a jos s ere kesse w ere juss

his isse do s kis are k iss ure koss

sals ess ore las s are l ess ure liss

she li ma loess a m asse d are loss

de m ass on ess a messe d u miss

he misse d a moss u mouss i m uss

she sum s an usse to n ess a mossed

the nass e r oss are nis s ure pass

20

the spas are saps e passé d a p ess

his iss are phoss to p iss erse s ips

her iss ed o plussed a pos s e sops

the pouss in e pre sse priss i p ross

so p russ are puss e r ass u quaiss

these riss o r oss a rous s ure sass

ye sars a rus se to sas se me schloss

de sciss ore ses s an eiss i sos s

the siss o ns its an asse ye s piss

me speiss e st rass or uisse di s tress

the strauss an ace de s tressed a s tuss

for its are suisse where t ace re t act

the taft i c ate wit h aste were talc

here tant or as t are tau he ta stes

hence tat ers ac t an aut ore t ec

he tat s an ect ure te chs in echt

so ted ere tec s an ense we t empt

his em i t empe so temse me t ens

the tense w e tents i sten t in enths

her erm o tent h are tre m u term

me terce di crete wi ste t o t est

the t ests are tete w i teut o tet

where tha ma t ewt a thaf t i thirt

ye thoft a tiao so tidge wa th ou ght

then ild a n ile whe tilde were t eil

ma tei were l ite so tile the re stiles

re d iles ure tile d are tilth ire tilt

so ti m ere tri wi m it ere timps

thi s ined a tink e tir ire t ined

the rit are there w i tri he r irt

me t oe was ote he n or an omb

he dotes a n ow u tombe d in onk

the tonks is op h a tophe wil l ose

thus ught a to se were tou to t ret

the totes a t rest i t ought are treet

 my ew es are tri fo r ibe were trews
 some trib e was ite to b rite the crit
 me tric ire t rice when ims are t rim
 the trine w a tripe re triste ma t rine
 he t rimmed a trite to t roic a tud
 bu t ute with ule were tue wi d ut
 the tui le ti tule no lute wa t ulp
 so p lut o tu m is une mut on
 his une d are tur r e tute to twank
 he tunes a t were so twins are t wink
 me t wine wi twirk u t wire re twirp
 her inc t a twite do t inct ure tind
 hence tit i dint ire tints a re st int
 tot its a s tints ure tost else t rant
 me tret o tris t u t roa wi twist
 your ul t i t roat in ast o vast
 the twi t avs e r a vat i t wit
 where vats o vec t are t wits
 vic t or e vet s a tev i vest
 he v ests a vet i v irt are triv
 me vor t erse torv e vult i wan st
 the wal t o w arts a wet o tew
 his ewt a wet s e west on ew ts
 she wets a stew o w hat s a wests
 the w hift are wift i w ist a swit
 so w its are wrap t ere wrot i wurst
 me wurt in es t ese yes t else yets
 my act o st ey i zat a re cat
 you r ant e ta c ats on a s tac
 the tan s i cast are sca t e sant
 so stan s a bant u bra re b randt
 me bran t e cant s o nats e chant
 his ang er ant s a g ant ire stang
 yer ange d i g nat ere gan u gant
 red s angs are sang a g nast e gnats

you r ang st a gra were tanh i hant

me grant i jau so t angs are j aunt

the kant i t an ere tanks u s tank

he jaunt s a tank as ants are k ants

he tanke d a not ere to n or nantes

the sla wi st o were s lants a ston

those ton s o snot e pa nts er arn

she p lants a tarn o t rans i rant

reds en arn t in an e rant s arnt

he tarns a scan t i sanct u can st

you r e vant alt e slant s a tal

my erse sa t on a n ats i sat

so b art o sats u sta re b alt

the brat e b arts are b rast o best

he bests a s trab ere brat s u bet

she bets o blart i bla t else blunt s

we blush t an oult u r unt ire boult

the brech t a bort ine brit ere t rib

so broast are b rows t i capt u cart

here t arc erse carts a c ert i scart

ma car te de rect o sc rat e certs

me lipt o c inct are pil t ire clipt

the c lit o cont i crop t ure cust

the cut i scu t erse stuc u d art

so cut s a dalt o tard ere t rad

me drat o darts a n ads e d rats

the strad i d at are d ault u tad

for d aut erse dawt e twa d i deut

me dic t o dirt else tri d e strid

he r ift ine dri to drift s a drop

thu s uct o ducts a d ust on eft

he dust s a dwe wi studs o d welt

the f act is eights are fe t i fart

me t ef one facts a fa to r aft

the faus t is ef ere f as are saf

23

hi s eint are feint i flau to f laucht

me fl aught a fle t as ocht u flocht

the fost ere s oft ise frat ure g hat

ye giust e gre t ere g luts i hadst

he hadst a hat ire tha w i sh at

she hat s e t ash a heit an ist

me kha t u khe ti khlis t or ep ht

the si t ine klept a mant u t ram

so mar t i sits a khe t ire klepht

he mart s a t rams o tra we smart

the moit are m ough t or ult a munt

where nant i neu t er och t en olt

the noct ur oin t are no t er out

we n olt e pec t a pen t u p last

ye s plat erse per t a terp i phit

she p lats a plet else p lout u plat

the poul t are polt an oul t o plet

me po t an opt ase to p ere pots

red opts it uftt else post a s pot

he top s u stop e puf t are print

the s pots o qat are stop s else quits

where posts are p rin ts a squit er int

me s prints are r aught as aut i reft

there r ets ers erts an ort are r ort

so row t one tre wi rup t a saucht

me saul t a saut are scept i sc hoot

the schu it a set u schel t on est

he ets eet is else s te were sh et

me sh olt i shewt a sh eet o skat

we skif t a sk ort ere skut are sluit

me smarts are s pent in oi t a spilt

the p lit u splirt e splurt a s prent

where spret o sprui t e st art a stilt

thence s tarts an ilt or ain t ire trat

she s tilts e s traint ere st rat i tilts

they str one will unt a stru t o tarts
he struts a str unt in tatt ers arts
the tot s are titt e tot t ire tratt
we twatt or ut t a watt i w itt
the watt s a y att u yett o zwitt
hi s att er it a batt erse bet t
the bhat t i bett a re bitt e blatt
ye bott e bret t on itt ere but t
the chatt er o do c outt s i ditt
so sid ette fat t are fitt o f ritt
the gat t o glatt ers ot t are gott
ma g ritte wa hat te so hitt e hott
the hu tt ore jott ere k att a kett
me lett erse lot t a m att an etts
we matte whe mit t u m utt o natt
so mutt ire n ett in otts a rent ott
where n utt e patt ere pet t a pitt
the platte wa plo t u p ott e pratt
me putt o ritt ers ut t are s chwitt
the scott ise set t a sit t ere skutt
here smat t if use d an utt i squatt
de sutt on ute will uu c a d ues
we vru m an aube to c lu the beuys
his ulc a b lushe d a cul o scul
so luc a culs erse clue s e c luck
me luce we r uc as uce wi c lum
ma c ub i cu be so dulce ti cud
ye r ub an ulm e cue re c ulm
we cul p ers ues o r ued a cult
the cum o cul ts a n unc i cund
de cun ore cu ne w ill unt a cup
the cunt s an uc ere c ups are suc
his ucs are s cup ere cus erse c usp
red uspe d a cute wi dru re c usped
the druse wa s cute to du d e cupped

25

the dude s a dum as ums are m ud

his umb e dumb s its un e re dun

her und er an d uns unce to n ud

me du ne wi nude a dunes a d ung

me dunse we re pud u du p i nudes

his pud s e dure so d upe will usk

their upe d are rude do flu re d usks

the flu me we flung e flute wa f ug

her ute s an ume re f lutes a fumes

his ume d are fu n a fuse to funds

the toff i glu fuse d ust ore g lug

me fut ur are where glu me w i fust

the glums ar ug ere gou d i g lugged

me doug an ouged a g lump o g oum

he gouge d a gourd erse gout s i guib

his uile wa g uige so g uild e guiles

her uil t are guise to gul else g uilt

then ulps ire gul ch i p lu wa guld

we plu g a g ulp as ulph is gult

my ums u gum ar ugged a m ug

the gust o m ug s a gums e smug

to m ugged a gusts e gu t i mugged

where t ugs a guts as ugs are ug hed

for eug ine tugged on eug h i h uds

the hughe s is u h er ulks are hulk

his ul me wi hum our um p in umph

the hulme we hum s is unt e hump h

me hu me re huns a n ums e humps

the hunt i s umped else thun ere s hunt

hence hup e husk are hu t in un ts

her uth ere knu t are t hu do lub

his ube w a blu whe bu l i dul

me lud are b ue wi l ube to lum

for mul e lumped a lu ne w i lunt

red s url i lurve were ru l an ust

me lust s are sult an uls t ere luv

he r uvs a vul o r usts are stulm

the muir is u le for uir a m ulct

de mule s ire mute so n umb a plus

red umbs ire p ule e put sch e rhumb

me slu wa n umbed in ul ms erse rhus

his slu m ung o for um med are slung

he slum s a spruce so spu me wi sluts

de spu te tis spruced ire stru to st unts

thus upe wil l uds um st rums o suint

the sud an uits a stup we strum me d

me sui were s uits a su m ere mus

she sum it up i s ui tes a sumph

the sun i snu whi le s uns ar unk

we sunk a su pe re sur d o tusk

the nus i t usked a ru t an aucht

there tut s an aud it en au st ut

his aug h a dau fo r aught is auh

her auk an aul d if aune wi l aun

their aun t a taun o n aut i baud

the n aunts are saun t er auc u baul

me cau so b auds are baulk a c aught

the daubs a re cauk u cau l an aulked

they ause so c aulk i chau we cause d

the clau de ma d au la clau to chaum

me c haunt e claus it s ugh a daunts

whence claused it aul d ire claut i d auw

here fau were faug hs en aults a re faults

the faulds aur d on a fause wi f aurd

sau l auds are f ro wi flaunt e fauves

here fraud s a gau for auls a f raught

where gaud ire g auk if aul e re gaul

their aug u gauge d i gau m are gaunt

ma g aure will aulse me g haut a haugh

we haul se t he haulte so hau wa hauled

t heir aum is aun ce so haunce wi haum

my aun ch a h aunt at auyne wa haunch

tats auyn i hau se th a haute re haunts

me hauy ne wa jau tha t auds a jaunt

the jaunce wi lau f or aun d are lauds

he l aughs a launce when aure wa s aul

de slaugh e launched a l aund e laugh ed

so l aur are m au though aul erse mauled

maud auls a m aunche to m aund a naught

her aunched are naun t i pau to n autch

pauls au p i paused u sau we sauced

pi p aus a scaum aure scaup i t aught

we t aunt a spauld u tau be wi scaur

for ault are taunts er se vault a t aut

waug h aults a queue fo r ogue ti yaud

the rogues are roque whe n u wa r ued

hen ce rues a r use where sure wer used

sues used a s prue to suede me t ongued

her orque wi toque ma t rique de t orques

his ogue a vague tha t ag ue through vogues

w here blues a b arque do gue yer en agued

reds agues ire b asque re bisque do b lagues

the braque wa bogue no b rasque we blag

her ig ue then ogues are brigue were b rogues

we brusque ma c alque so cangue re c heques

me chique t is irque where c inque can iques

de cirque wa c laque ye coque wi c liques

me d engue wer aque to d igue my irques

the drogue ca n ude for euds are eut

the feu ds are feuille wi feute to f uels

me flasque were flue so flan que re f uel

his ugue feud s on el se gigue can ugues

sue f ugues els angue thus hence ti s ued

her ues are g lue when ules a re glued

the gang ue were gule wi l uge we glues

28

me grecque wi g ue to gre t he hague

 hence g uests a hue to haque t he hues

 jacques eague s a jerque wi l ang re hued

 were lasque de logue re m arque ma l eagues

 he r asque masques it as osque we m orgues

 she mosques a nuque wi th or gue he piques

 the pasque sa p laque do pique d e plagued

 here pulque wa s en ough in ou r oughts

 we p ouch a pough or oul else p oulp

 her oul p e pouche d as out is ours

 he pouts an ou p ere toup e r outs

 ye s pout a stou p ire tous en oust

 there stou wer ouw as ousts is oud

 the prous t ire prou re so wi s prout

 me strou p a rou fo r ou we roughed

 dis outs are rou ge f or ous en ough

 my ouse w e troughs i rough t an ous

 the sou can our t a rouse where rout

 he roused a trou hence t our e r outes

 the stour is ou red a tours ure r oust

 we routs a toured ar oute to r out es

 me cou s ins ou re scou we s cours

 he scou r an our to sc ouse me scout

 we couts a scourge wi s mouch o s nout

 her ouk are snouts u s ough are s ought

 the souk i s our ed in source soul ourced

 where s ouls ar oum un our d are soum

 the don oul s oun d are source to sour

 he soured an ours e sour ce d a sourd

 da n ounds a stound o st out i stounds

 the sout i stou were w oun ds in ough

 we sous the s out h e spous do swound

 thou s touts a though e strou d a wound

 me swounds i s ounds u touch erse t ough

 re t ouched are toughs u tou se tis oughed

ye tout a stout a s oupe were t rough

me trou pe wil l ous ere touts u stouts

the trout is t rouse so troughs a re vouch

she trouts a v ouched or oul d a wough

me wou will oung a w oulfe to w ould

you r ouve wer ouave whe n it i wrought

her oungs are your s if ouve were y ourt

youve young a you th or ouche wa z ouave

me b louse to bou will ouche the y oungs

the boud in ou ne wi b ouche do bough

so bouge were boughs u b ough t in oun

he boughe d it ound e n ou there boun

she bounce d an ounds ere bounds a r ound

his ounce bour ourg i b our d on ourn

me bourne re b ourse wi bour g a bout

so bouse w h ere bouts a brou to brough

ye choule can ou d a chough e b rought

he c louds a choule so chou se we clour

the cloug h is clou with ould e c louts

me couch is oun t o r ough else could

her oup e couche d a co ugh u counts

she coughed it s our b i could a count

de coup on s ourse did our t e bourb

so p ou were coups a courb in ours ed

he coursed ore couth un ou ve t o croup

ma c our ts a croupe we crouse wi crout

no d ou will oud erse d oubt ore douc

red s oup i douce we re pous i dough

me dou p else dour ere d rou wi roud

her ourd i s oused ere d oust a dout

she d oused it oul el flou we d rought

me fl ounce wa fou he n its i floured

so flouts are f ought a s ouled e foul

he fouls a founts e re f ours are rouf

me frou we foun t in ours ure f ourth

30

my oust i f roust a frounce wa g lout

t here roug is ou g ire g rou can ound

the grou ch in oup ere grou were d oun

he grounds an oup or e grou to g roused

where s he group s it and oult are hough

her gr outs a hou so h ounds ar oused

the hour s ire house to hou t an ougs

me joule wi jounce re h ouse d a jougs

we jou r ere j ousts i knou were knout

lou louts are m ou ch in oul an ould

there lout is oul t if oun are m oul

we moul d a m oult on ourn a moun

ye mound a mount e mourns i m out h

the mouse re m ounts a smou se with ouths

red outhed is ught a s oul d outhe mouts

he mouths a s mou for ounce do m ought

she noughts a smou t u noul d are nous

me nou l ore pounce ye s ou we round

the pound i s alves i va c ar ounced

his oun a roun d if alve ma s ounds

we trounce my alve fo r alv ar ound

their ane we valve s u na ve to vang

where van is arv erse va r the v anes

the vane w as arve re v alved e vant

he valves a n aves or vare m e vaned

she raved it ave so drave we re v aunt

while ned i v ar ve to vaude the vedd

he vaunts a ve g as ein a re veins

the lev in erv are vel ore ven

so merv i n erve re v erm i vends

he verb s a ve rn e venge were vent

his erge wa ve rged o n erve re vers

the verne e nerves e re v ents a serv

he versts an ervs u verve we v etc h

vic erst s a ve uve while vice de civ

31

part three

the vic k on uve wer e cive re v ich

where v is are s iv o vint e re piv

the vi p in ive wa v ise wi v ives

me vod are v oeu wil l ov to v ogt

so clov e vote s a st ove we d ov

de v ou we re v our as uv are aic

he r ouv a vrai wil l uvs ere v raic

the guvs ai c arve so v ugs a vr il

i vre l u blive ye bove we v al ved

he do be b rave f or ave we wh arves

me calve we breve so c arve sa w ave

red s it is arve d i n eves erse cav

he calve s o vacs i c lo w ere caved

she cave s i n ove else cleves e c oved

the c ove where cra c love s it ers ives

your uive we cuve so d eve wa c rave d

dave dive s in ive the n elv e ro vide

me cuive wa d ervc to d ive wi d ove

the do ves ar eve no w el ves are fav

the de duve dive d a d rove with eve s

the seve wa fave t ha g ave me f ives

the fla v in ave we g ive to g loves

me five we re g la we give s or oved

youre glave so g lo were vul g a g luv

the g rove ti s alve when oves i hal ved

she grove s a have we hi ve b e hoved

he halve s it ive t hen ives i re hived

my el f in ove wi st rove re v ies

me jive wa hel ve f or uve was ive d

he jive s a j ove bi juve t o knives

the ko v ac s auv if o ves are jived

so kive wi l erve we l eve re m oved

melv i nerve s on a m auve d id oov

the n ove re parv i p aves a p erv

he pave d a n erv and eve wa r iv

34

me po v ere preve s aw evs are p riv

the reve w as ulv an ave d a p rov

he p roves an ove so va r ire p ulv

me vare to r av is eive w it h oved

the rev a rave d id a se w e rives

he r ove rave s on a ver e revs

she ra v a reive wi r iv e r oves

dave s ive save cri s o vase we r av

we sav an av erse sc r ive ye s erved

me selves i serve d o ve rse re v ersed

red s el ves u shrove so sk ives e shoved

the svan are sou v en arv es erse t arves

thei r aves are suv ere vans a re st aved

ma st arved ar erve to st ive st oves in

the stra v in ive strive d on e to swerv

the don erse sua ve so s ueve do st rives

me svelte ti t arve el se tave were s werves

she swerved a t erve no w aive s aw eived

the thaive to t hieve if ir ve w here thrives

hence th rave we thr ove so torve wi t riv

his irve was urves e re t irve do t roves

we t rave ma t rove that av a t urves

where vav a veps i v euve wi ve sp

so vivs is wh elve wi v ivs ure b ruv

t he b ruvs are va when ive d u dev

we chiv it er v erse devs a re d erv

the re ver d i ve d are evs e ved

hence fav s a d iv else div s u fav

ma g av in alv are v ag a g ov

he govs a jav ere hi v ar e v og

kev its a l av e vla d o sla v

the n ev i s lavs u nov a v on

me lavs are val s o ver t a ven

we p av ere va l i q uiv e vap

the wa c a t rev u terv i w alm

35

my ant i s awn a s o wan t arn

me wa d o wav e r aw a w arned

so wan a na w ave w aved a w atch

t he w eb er ews else be w in ewed

the we bbs are we m ere m ew i went

me we r ence rew a w hale to w het

we w hare wa whe so her e ma w hey

w hence ye w ere mine wi w hid a whiles

whilst on a whi m ine whine s a w hist

the w hits are whi do w hite he w hined

he re w hines ohm u who p are w hod

the w ho ye w hoa so were no w hops

the whoppe c an ild a wil d e w il

me w hom e w ha re w hose to weid

de w ide ye w he re wi le de wilt

the w ilde ti w hi m e wi wilts on

me wife ye w he were d wi do w im

she wiles a d wile when i w are wi n

he r else wa winced a w ins e w inds

the swi were swi n e w ine re w ined

he wips a wi p ure swi wil l ip es

ye w ipes erse wise so s wiped a w it

the twi wised u p a w ite here w ives

me w ra wi swive do w ra to w racked

wren s acked a wraw i w ra d o wraw

so w re m ine wri ye wri t are wrist

he writs a wro s o w rite wi w rick

she wroat h a w rote wi ric a wurtz

neds aw p a yawne d ere wade to w uz

re d awe d an awns else yaw p an awm

the d awes i ma w as awle d are wam

she wades an awl i f ew e wil l awned

the daw ers e maw s a ba w i bawn

he b awls an awn u re w are c awl

she brews a ch a w ere wa do c hawn

36

m y ews ar aw k else haw ure was and
d awn awks a wi f or awke wa f lawn
she w ands a wah er aw ned e h awks
the hawes in aw se we wha t o h awm
me jaws are kaw en s ank are he we d
ye w ak an aws u s hew erse j awed
so kwa were ke w i f an ked is awns
my ewe kna w on a wan k else k new
she saw i swa fo r aw n are swa nk
me lawne we pa wns e nawle wi s pawn
he p awned an awle fo r aw led ar awls
the spa wa s wa t ers atch ire p rawns
she s prawl s a t was e wats are swats
her awed i s watc h ere rawls e hawn
the caw s ew its ere thawn a re t hrawn
she claws a whe to w he w a l awed
the wa c ard s on erse crew s a draw
drew aws a no w e wards i sw ard
red s ew a re few u we f ere ward
me w ag ere fla wed an d aws i flew
the le w i gaw i f its are s wag
he w ags a na w ere swa here g aw
she gnaw s a fle w in ang erse m ews
the s wang are ews u re w are s mew
me pew s a we p else ew i s crewed
they spe w a n ew e he swi we sew
so we s is ewe d erse sh rew in ath
he l aws a skew u sla w e spew ed
wat e me w er axed er aix are ta w
hi s ax is awed as ex ere tha w ed
the zeux is aw t u vi e w e vrouw
me x eme tis axe whe xin g are y ex
t he blix e bax ure b oxe d in oax
so c aixes u chou x else c alx a coax
the bron x is oaxed an ux i c ox ed

37

we d ex in ex o r ix are d ux
the dix i s ex e for alx u f alx
hi s aux i f axed u faux e r ix
me f lax ar ex a f lu to f ixed
so f lux us ox a flix e f lexe d
the g lax o fluxe d a foxe d in ix
then inxe d a g rex iv uxe to he xed
the ho a wi h ox is eux ere j eux
he ho axed a j in x as anx e kex
the knox e l axe d a lex is an xed
the man x de l uxe we l anx u maux
so m erckx are m ex ined ixed i t up
the m inx u mix t are mox e m ix
me m ux i n ax or erse n ex us
the nex t are nix a n oax e n ox
his e ux is oix erse nox e m o xed
we n oix a pax ore phl ox else p lix
he r u p lex oixed a p oxed u preux
me p rex are pr ix a pro x ere rex
the r ix er o ux are rou x erse rox
you r ux a s ax on ioux else s ex
the sixth a s exed a s ix o sio ux
he r ixth an inx i s nax ere so x
we s phex a sphinx in ex t a t ax
so tex a n ext are tex t ire t oxed
me text s ix t on an uxed o t rix
they inxed a xu wi t wix t i v ex
de v exe d a vieu for oix e vieu x
me v ix else v oi a voix ere v ox
she w axed a n ax o yach t i xan
her ey are zax erse y ale s a y ang
ye yao me y arm u y ate to y auld
ma y es are say ire y ede wi se y
he y en tz arent eyr a ye h u yep
ye r yes a yenz i yer k ere y ern

38

ye yers are y ers e so y euch is euch

we y euk a yez else yi g one y in

me yin g a n oy are yip es o yips

the y iz are yite to y o me y oaks

so yobs are yoa wi yoc k e y oax

the yo de w ere yog h as yok i yod

he r omps are yold a y om p u n oy

yon om pe e yong ere yonks are yom p ed

we y ont i yuc k else yuke w here y uh

red ay ed a yur t ore y ule were yus

for ayle tis ay me wen ay ne re b layk

the boyle saw o yne wi bye t he b yes

the byr ne w a byre ye byte de c oynes

he b ytes an eyn u cloy ne w ere dayes

the doyles a re d eynte for uy p erse cuyp

the dyce wi d reynt a re dyne she d yes

he dye d an eye w hen eyc k aint eyed

her e yed up ey ght and ey le was eyl

their eyes are f ayre to floy te d e fley

my eyre s ur e yne wi flyte to f lyped

me fyte wa g leyre f or gly de do g ryped

the gryke i gy be w he gye wa g yres

no g yle wi g yse re g yte me heygh

the ho yle ma g yve mi ne hyes a hydes

so h aye were hy ke w i hyne do hyles

the hype ti s oy ce so hyrse are tyke s

the jo y ce wi kyle w e kype wa hyped

hi s oyd ere kyte be kythe s are l oyd

he r oy ds a loyds else lyme wi l ymph

she sloyd u lyre we r yle wi l ynch ed

hi s ayst are ly se t ha lythe were lyres

he moyes an oyl ure m ay st are m oyl

the pepy s is oyle to m oyle the p syches

pryce pyre s a p syche so q uey a rhymed

me rhyme wi p ryde royle s in a ps yched

his ay kh are rhymes ere sc roy le will uyt

me schuyt u scye wi scy the the n ay kh

de shaykh are sky ped a sly pe t o sley

the soyle we st aye d are sta he st yles

sykes oyt w as eyl e re st ye re types

he sty led it ay erse thy me wa t yped

me syce ti s yne so to yte w ere tyres

no tw ye w as oyte re wyte to w eyl

the ty ne w as eyl ere ya w i bay

he r ays a wype do ya b are b ay

she yabbs a n a y o b hoy i blay

the boy s o b ley if oys are b rays

they uy a buoy ed up oy s else c ay

he bo uys a buys ere c hoy are c lay

dis oye d e clay s i cloys a l oyed

de crays e coy o r oy e d are scray

she d ays u c ry as oye wa y ad

the ya di c ry s a d rays an ays

me scry are yar d a s ay are f ay

we fey a fla y ere fle w i g ay

he flaye d it uy s or e y are fley

she gay s a y ag er ey s el se goy

the greys a re y u wi g ey erse guys

where h ay a ya h oo ho y in uy

the y ha w ere yoh a s aks o huy

kay s uys arent oy if oyl i l ey

s he jays an oy l else yak are t el

the loy a re l ye whe my are y en

you r oye wa n ey ere ye de p loyed

reds oye d are p ray er aye re p ryed

the ra ye p uy up a yu p erse quay

here spra so y ar a ra ye t he slys

they spy a s p rays o stra wi r ay

me swa s tyed it a way else s t rayed

the synge way s in ere toys are s waye d

40

the toye be r aye do t ra so ray

she toy s an ays el se t rays e trey

me t way are yaw i v ye t hey wey

my ewes a y in o s way a w ray

the y ews are yay i za b u b az

me z ac a z on a zag i g az

ma zam i s it o m az a z an

so za we re n az i zap e z ar

the zapp a raz e r se ze wi z eb

hence ze d a zei ye z ine to ze in

the paz i zei t are zem e ye z el

we z en d a zep o z eze we zest

me z ho w e zhou so zi do z imb

de zinc i z inke do z in g a zips

so zoite we zoan e z oi d i z orn

me z orb a z oon e zoots a z oned

the zonds a n ad ze for az u b atz

me beez e b la ca n aze to b oozed

your onze we b reeze wa s ee z e brazed

fo r ow z a breezed i bronze wi brow zed

re ds intz are cize we c oze so c razed

the chin tz is utz ure croze wa c rut z

de d az e we d ozed else faze the druze

fitz it s are fe eze where f ritz is azed

he fazed a frieze to f rowze do f ree zed

she froze wh en u rze were f ruz u futz

her auze wi f urze de f uze he g azed

we gauze me geeze fo r it z i g lazed

she glit z a glo ze to g raze the gleizes

de grosz u gri ze we guiz e wa gun z

no g uz are g uze wi haze to hert z

the her z en ize ma ke ltz i k lutz

me laz o leutze w he l ez are lit z

the liszt a lon z e ma ze wi m iltz

so l iz a maze d ire m aize where mitz

41

the m iz en antz are m oz e nan tz

me n aze will iz a s its his ot z

we zi do p hiz ere pi ze ye p lotz

thei r etz are prez u prêt z i p riz

the prize d are raze d a put z e saz

roz rouze me sc hat z u sc hitz a schiz

she schmel z a sch merz el schmut z a scuz

the s pit z u spaz if eized are spr itz

we rutz a sc raze wi s cruze we s eized

me s ized it oze else snoo ze d a sneezed

he r anze wi squi wil l ow ze me squeezed

so s zem erse squize where st anze do t az

the z ems o tow ze thence toze we t zars

me t weeze tis eze fo r ad z are wheezed

she w anze me waz else win ze ye w iz

the da z i z eze whe y entz are zad

his aize ti b ayz a bl ow ze wi biz

so b oz e b lit zed ere baize re zob

the c hez are czech u c loze ti c oz

where f ez a fiz el se g iz ire zig

the gr asz ire grez ore glit z are h einz

she k rantz a k urtz ere laz e m ez

there m az ar iz a mer z ewes o z

the po z o zo so qu art z e quiz

me sez ure s wiz er ud z are t iz

hence ziv e walt ze d i v iz a whiz

so b uzz e w ootz are zizz u chi zz

thei r izz a crizz i s uzz er iz zed

me dizz o fizz a re f rizz a g azz

the fuz z a g huzz e gizz i hi zz

red s azz o huzz u j izz a j azz

the m ezz e miz z en ozz a m uzz

we n ozz i nuzz u pizz er se q uiz

t he pozz o r azz e schnozz so scu zz

me sizz ere sn ozz u snu zz i spa zz

42

we s wiz z an ad o t izz in izz

 ma da w uzz it e r ads a w hizz

 he w hizz ed an uzz i da s e sad

 we ba d a dab a s adge wil l abs

 she d abs u bla wi ba dge re b ard

 bra d oads i b lades e r ade wi bards

 ye drab s e roa bro a ca d in adged

 the broads are cad s i c ade to s cad

 he scad a d ace so gad u c adged

 me boar ds u cla de de fa t o daf

 she fad s a d alf if ahl a re d ak

 d an a ds are dah l u dal erse lad

 the la ds a nad a dan ce wi g ad

 dank a dance d it a s ag o g ad

 the da g o gad s a g lad u had

 we had a j ade to k ade the ja d

 me ma d a m aps a d am i pad

 she d ams a dap er uad a qua ds

 he r oads a skad adt i n a st adt

 so vla d i s ake whe val d i wad

 wad s ane wil l am a d ames an ankh

 ma w adge the s ame so du ca ne swad

 han k oars a kha n if aor are b ar

 hi s oar ure roa for ar b i t or

 the bra w i bar a ra b its ar f

 s he b ras o far as ar g us argh

where g ra wi r ag erse ga r a rags

de bar ge we b argh as arn e b arm

here barns a b ran else art h are b rans

 the bar nes i b ra ced as ach ere brach

 the barthe s ure bract is ags ure g ar bed

 me bra g ags ine where gra b an ag g

 brags a we r ahm s or anch a g arbs

 his ar be d is abbe wi g rabs ur arbed

 the brahms e grabbe d a b ran ch as ahm

the brand i s aw led as car b on ands

she brawls an arls i d rac el se c arf

the ri car d are wa cark s ure carp

carls a p are cra p i s crap e craps

the rach is arpe d a ch a wi scra ps

me ch arde wa charge d u ch ars are scarp

ye cla wer arme fo r am sch are m arched

he ch arm s a ramsc h e clart i c harmed

ye r arche d an ack els aig ure s crab

so shem aig s in erse c rabs a c raft

the crack s a c ragg e craig s u scrag

me crai wil l amb e wi c rags e craigs

the cram a ne craie so m ar i c ranch

mar c anes a cram be so c rams a scrams

we scrape to s cratc h ere cr aws are scraw

thei r awls in arg o n ag s are craunch

me cra were cr awle d a d arg o d rag

she drag s a g ard elsc grad is aw led

ye grads e scraw l a d ark e d ragged

the ran d i d arns a rands u d rad

red arne d are n ard ire dra r e drad

the draf t erse dradge wi d ram o m ard

where rau wi rawle can arf are raug

de dram s i d raughts if ar fs a raugh

we draw led its arfed ere far d are dr af

the d warfs are draw n in arce to f ar

their ames do f ra mine f arce the r af

he farm s i n ame whe farme d are frab

me frate were barf ire f ramed a s ay ed

the garn e r ang are r ang else t hrang

so grans anth am are grace were srang

garth ace d a g ranth i thra wi g nar

the graf ire frag ure g ram a ma rg s

de g rapes a gram me grane do g rand

so graph s an arge whe spa rge we g rasp

44

the g rave s is arg an arve wi g ray

me r ha was ar d ore harl e do har d

the d on i sha w ere har a h arms

f or arth ur arm s a rah u s harm

he harme d its erse so h arns are h arsh

me har t el se jar d are rath a jar

we tha r u t hra wi jar k en arged

the kr ays are kart er e kar u k raft

me k rang en arge my a rve par d on

the large ti l arve we m arge to p ark

my arks are yark i f ore the pa rk es

hi s ark e s parks are spa wi t arp

the par t on apt i s parked a p rat

me tra p ere rap t are p arts i tarps

the spar t an arps a stra p u s prat

he strap s a t raps erse ra w ere prats

she sprats a rat u pra t e wi p rams

he r are wa pra do t rapse me p rangs

de spra do r ance so quare re p ranc ed

reds uart a s pr ang u char i s charn

then arn a qu arts are ra g ore n ar

his erse g ar a n ere rags ure r anch

the rand is ar f or are d are sc ranch

me range wi s ca w ere carce he sh ares

the scarfe tis are so s carce ca n are d

he share d an arce ye carce wa s h ards

the sprag u stra w i strake de st ra fed

ye strand ere st ran ge wa r afe to straw

de warts are swar t erse str aws a w rast

me swarf a s w ar med if else trace tharf

so marth a th warts a tha rm e c rates

de tract s e t race for amped a tr acts

we tram p a st ra wi trance do st ract

he trance d en awle d a t rawls or arm

me s warth are swarm s as arth u warm ed

45

me w arp is arpe to w rap a w arps

she w raps an arpe d in arc h a warth

so w ra were yarn s in aak o w rath

he w rappe d an aa l i char in arched

she chars a ra m as a aml ar a an

her arm s a m ars e baa wi r ams

the baa l is aat h ore faa to b aath

he baa s a c aa whe faa we c aam

the c raal are haa so g raal e haa k

my aase we h aar e h aase re k raak

the k raa we k raal are laag er a ad

he m aa d a maam ers its a m aar

sam aat e m aas are naa m ere n aan

the n aat erse raa do p aa s ure raaf

me saa ti s aa g els e saale wi saach

the saabs are spa wi st a a do s aag

she spa d a saa d are taa l en aach

he v aad erse vaa l a waa can a af

the ba c on is a waa f ere w aal

me cab in a be d are y aas i cabs

the sca b alb on as alk a c ab bed

he scab s a bla we bal e scab be d

the lab is ab s ure b arre to b alk

me bas eb auc h u b alm a b and

we d o be bas else bad h e b ased

de b auch a beck on e d u b ecks

the debs a be d are be de wi de b

he beds a beh n els e beme re b ends

we b ene w hen ed are bent or e rm

ber m an is im b ers erb erse b ey

the bi c a bice whe be rne wi b ik

so b imm i bile we b irse to b in

he b inds a nib u bi r ire b ink

the bir t are bi n o bints are t rib

s he bits a ti b ere bise de brits

46

he bites a bis t u b is are st ib
i black a b la w a sib u b land
so b last o bleu wi bla s ire b lah
ha l its a ble to b l ende wi blatt
he b linds a bli we b lau do b laud
his erse wa blir t u b lit a b lodged
de blite do bl o so b lu re b ludged
he r obe we boe f or are bo de boh
the boh r erse bods are ho b it s obs
he hob s a b lote to b oke the hobbes
me bonce wil l one de b ond a b ones
she bos e bo p ere bose he b one d
he boppe d a b osh u bou wi b oyd
where bosk a bo t i b oul u b red
so b oule wi boyds a re b rem e bren
the ber n e b reme me bre ns i brent
red er d a b rer or b rere were brerd
the bret on e bri do b reug u b rey
ye bri l are b rimse so b ris o brisk
ma b rine wa borne wi b rome to b ronc
mine brone wi brung el se b ude we b ugs
the bruc h ere bru where g u b ire bul
ma bu re b uh l a b uil u bulged
me b ui we re b uilt as e wa build
the bum its else me b um me d e bump
he b umps a bums e bumpe d u b umph
the bun d erse bu n a b unce with arb
the bus he d are bunt a b urh o shub
bab s ib i b uste we b i wi barbs
the babe re b arbe d a b rab else bib
she bibs a n ab as ibbe d are b labs
the na b ob abs are blob s it ab bed
he blabbe d a b obb i blub or o bbed
me b lubs ar om b e r ibe wi bombs
thei r ubs are bei for ibes e b rib ed

47

part four

 so bulbs a b urb u c hubb a r am b
 our ub be d ar ulb ere lub i c lam b
 t heir c lub an ubbe fo r obs a s cob
 the cob b i n ibs are cri bs ure s crib
 he c ribbed a drub i bur ds i n ub bed
 the crab be do dub and ub we r u bs
 so bu d ud s and erse dub s a b uds
 thi s ub be tis ib ere dubbe d a d rib
 the bri d ibs her e so b i wi b ird
 my e b o d ribs an ebs a re b irds
 me fa we r eb b if eb be d ar ebs
 red s ib ens u b and a b are f ab
 the d e bs o b ef am ubb o r abs
 so f ebs ere flu b an ilb else f rib
 the fub s a ga b as ab ti g abb ed
 she bag s a g ilb e ha b it ib s
 he r ib ere g li b in abs are hibs
 he jab s a b ah u heb i j oub
 li b uns else bli wi ka b a k nub
 she m ob s a bu n er omb u b uns
 the nu b a b u snub s ub are p lomb
 me p ro b a p ub erse re b an ubbed
 we pubbed it s erb a s ub e w i ber
 he p ubes an erm i n ub be fo r ib
 his ubes a b re so c ru b ar erm
 we d o b e rib ere bur in ib bed
 here b i me ri b are bir ore r ibs
 my ur b an erb s a bri wi r ib bed
 here r ubs a br u so b urs are s erbs
 the scrub s u sla t o she b a sh erb
 de sla b a l abs a s ubb b ere blas
 she s labs a slu b i b lus e slub b
 ye s o b an ob s ere bos are slub
 her ob be d a stab i f ast is ub bed
 s he bats a bas t o t abs ere s tabs

50

hence bot s a stob a s ats a re st ub

no b uts e re bus t ere stu wi st ub bed

the stubb s ire s ub a n ab be do wabs

me re bu s ure fo r ub be we s wabs

he wabbe d a t its if us ts ar ub ed

here t ab is ube w hen om b ae b at

we t rab b a t ubes a trom b i tub

bu t i n are b usts and urb ore b rut

the bur t on a ws an au b erse war bs

she bra ws a cache wi c loche t o b abs

hi s ab e crè che we croche wi d ouche d

her abbs are c ruc he re d reche the b am

your am bs and eche ye fleche to f ich ed

the frac he w ere g ruche the m iche lin i med

you leche wi l oche to n iche the louch ed

the louche do m oche wi t h eir a chin es

no w o che ti nowche de r oche we ch ored

me rotche ti s uche whe r uche re t ran ch

the r uched i s eiche were siche fo r ach es

so t roche was ached a t us che wi c ack

ye b ache were b roche to c alk a c alm

the boch e calm s own a mal c o c ank

he case d a c aste to c ee here c edes

hi s ice we re c ei wi ceil ere l iced

her ense re c ent s in ept el se c ept

the cen se p ect on a ces te wi c ern

me c ha ch a cete we ch af t an ach

they atc h a c hah u c hak i c hal

so char t e t rac h a ratch ire star ch

she cha rt s u ch ase t hen er a chack

tha t ack ase d on are chas e d ore chal

red s ang e wa cham u chanc e d a mach

the change wi c hap e can ap t e ch aps

me p atc h is atch ed i chase d a charr

ye char and as te wi c have to c h awl

51

the c hast e w e chay in ech e r est

so che sa w est s u ch el p are chert

he c hests a chese wi c hew s erse ch es

my ew es are chich i c him m u ch ield

the childes is im b a ch ewed i ch imb

she chime s an i ch else nic h u chins

we ch in ch a chir m an ocs are ch irt

he chive s u ch oo wi ch lo w e chlor

de choc s u choose do c homp i c h on

the c hop ere c hose so chri s e c hrist

he chores an uch e c house re c h ro m

re ds ums ure ch romed i chro fo r un ch

the se m uch a chump s un use de c hum

she chum s a ch u b arent ump s ire chun

so ch use were ch ur r i ch ute to chut

we ciao de c ide the d ice d are cig

the cigs e di c e ma c ime wi cinq

hence m ice we c irc i cite wi c is ts

these cit a n it es are na whe re c ites

he r an cs ire ti c ure t ice were clan

hi s an cs e tice the tic s ore l ancs

the c lapse wil l imb a c lans i c lines

so clints e r im bs a clime wi c lim bed

he clone s a c lite hence c lose to c lot

she clot s its ote so clo t e were c los

ye closed e do c else c oe de c oct

he cod s e c ode the do cs a c om

her om bs are co f or omp ere c ombs

the com p o co me w ere noc u c on

she con s an onc ure c on d are scon

the con st a cone wil l on ce to c ones

hi s ope wi cone d are con v ire c ops

he c opped a sco w e s cope fo r opes

her e cope d a n ocs ere coq are c os

s he co sts a sco where t o c ur ost

52

me co t is oc t else s cot ire so c

he cot s a co te w i cred ere s cots

the c re m a m erc e cre pe we crept

she creps a c res en es ts el se c ried

thei r est are crest s i c rise we cri es

he r ime to cri m are crime so s c rim

min e crine my in ge so cri ti s in ged

she cripe s a c ringe wi c r isps an isp

your e hatch e d in a crith o re c roud

the catc h a c inch u c latch e cl inch

he r itch i c hit and itsc h are stich

she chits a s tit ch e n it ched o clitch

we c lunch a clutc h i conc h ere crotch

the cr ouc h u c runch ar utc h i c rutch

me culc h is ult ch a cult ch u c utch

the datc h a d rat ch a dre w i drench

tod s ut ch i d retch i f etch e drunch

reds il ched a fa ch e f et ch ire d utch

de f inch i f itch ure flaunc h are fit ch

we flinch a n at ch u ratch e re f ratch

his at che d a ganch e t cha t he french

so tach ere chat s a g atc h o g aunch

de glitc h i aunc h a g ulch u g rinch

m y en ch e grutc h are gunch i hen ch

we heuch a hit c h as ooch i ho t ch

you r un che d a hun ch an inch i hutch

the k elch are ken ch or inched a k erch

the sk etc h is it sch u kitch as k itsch

so kl atch an oo tch i k loo to k nitch

we koc h a chok i n ut ch u lanch

he r atche d o n icht a r ich e latch

hence cil u l ich t are lic h i c hilt

hi s un ch a r ilch a lunch i mat ched

ma ch im ere chil a milc h a re m inch

now ulch i s utc h ans at che wi misch

53

so mul ch are mut ch ire p ilch ar itch

the m unch is orc h as ouc h e m itch

hi s at ch erse nitch i pe wil l ot ch

me n at ch its otched a cho r i p anch

there p arched ar otc he w he pech a c hep

this erche w ill ech as erc h are pin ched

he p erched it s in ch e r anch ere quetch

me pit ch is otc h ers e plan ch e p lotch

we prit ch a p orch e n uts ch an utsch

the putsch o r ot che so ric h ire run ch

ye churn are s chli fo sc hu ma scot ch

me schli e schu l u c r aunch ire s creech

we scrinc h a s critch if onc h u s crunch

here schul ch or e nch ar un ch ure sculch

where s chench i skinc h e n ut ch are slatch

hence s leec h are s lu wi s match e smutch

be smirche d are smitch if atc h ire s nit ch

me sna were spetch el se p lat ch a p lotch

she ch ants a squench e re stanc h i t aunch

the ste we re st ench ure stouc h ore st rich

mine such an itc h orr t enc h ure t etch

the titc h ire t renc h ere tric h are trunch

here t w itched a vic h em ac h u wench

there vla wi ch ore b e w it ched a winched

though et ch are wrenche d a y ech ore zilch

the ba c hs arent an ched ure cha n ire chab

we b it ch a b ench e bunc h are butch

ye blanche de c he w i batc h i b lotch

he r ors ch a bort sch e bos ch an acc

me bac c a b run ch are hic c up icc

you r oc c a m acc ins ac c ure succ

the dah l ar e y acc ire dar d an aud

me d au d i d ebts ere dec are c ed

we de m u m ed a m ends ere d emd

den end s a d ense so d em n e neds

54

ye m end a den s i d ep th u s ned

 ne d epth s an esp u de s are d ey

 the dhal i dha r are dho le t o d id

 we d ik h a d ine for inde were d in

 he dine d u ni de w he ding a sn ides

 the snide ti s ing e for is c i d inged

 si d isc s ure dings u sid s are d itch

 here disc s a d ite wi t ide to t ied

 the mod s ure d o me d iz ere d om

 we d ome de m ode bu t omes ar o des

 he dome d a d onk ere do pe re d ont

 she dope s i p ode so spo de w e dop

 de dorm s u d ork ere do t are d ost

 me d oes a r ose whe dose do s od es

she bods a sod s ire d ose d a b odes

 we d ots a s to d and oz ere doz

 the dzo dot h un a d re d ire re dd

 her ent are d rent an ed d u d rest

 de t rend a dro w i rok weve d ried

 ye du hs are h uds and uh ds ere dur

 you ru ds a d ru wi d wa where d urn

 reds al m i d w alm u dz ho we dwem

 you r eds are se d i f eds erse eld

 the de s eds can re le d are s eld

 de sleds o f end e fer d a f i end

 fre d o f ends erd as ir d are fe rd

 he grid s a g ird i glo d a g old

she gu ards a he d in ul d a huld

the hind is in d are n id ure d id

 he d ins are kin d er aird o n ail

 me l ai ti drai we l air d a d rail

 so je d od s in a mer d else n od

 the don is on d a d ons o s nod

 the dao w as oa d are pa d o d ap

 he p ad s i p ods ere do p a s pod

55

the pra d o quad s an ar d o r ad

 she r ads a s qua d as ards i sar d

 the re d ore d ra wil l i t erse dras

 so re ds in ir d are re nd ire d ern

 he r ends an ir ds u rids a r oald

 hi s oal d ar ou d an id ers ud

 we shroud a s pa ld a s tride the sp uds

 their ua d are ten d a d i wi st end

 she squad s a d ent i t ends an und

 he d ent s a t hird u tun d are thrid

 the vid ere vil d i d un t el se divs

 he r o v ids ew a wads a re d aws

 my e wed s in a d wi ne we wined

s he w end s a d ews u yid are nad

her end i s ew ed an iel d or an ds

 dans ald e r ads a ba ld e rse b ield

 the sands i s a d a b lends are b lad

 hi s o ad is ar ds in ilds erse c had

 the s o ads ar e ld ere c hard e child

 she b road s a c and u col d on add

 dad s e m ad ds in i sad d are b add

 ye bid d ere b ladd a cad d ure d odd

 the bud d en e dd a c od de to hadd

 the dad d a d edde re f odd e h add

 the jud d i k idd as od ds are m udd

 the ladd e d ods els e p rod s ure rudd

 the ri d d en are schadd u p a sch udd

we s hudd erse sud d a te d d are tidd

 so duds ache whe n a w add i s ea ch

 hi s udd ers ea k in s ake mae dud

 dud s ame d o kea wi m ea wer e am

 hi s a wa s ean i mease ma y ea mes

 u m ea we nea wi th ane no r ear ed

 red s ear are s on are rea d i d ears

 fo r ase wi r ase can ar se de s ear

he sea rs a s are wi rase d an ars ed

da d ears an ear n u n are he r ased

he d ares a reads a s ea rns are n ear

we r ean a ranse whe n ear ne d e nears

ye s nares a r ear t as ease ti n eared

me hear t o f ea rth i rathe to hears t

hi s ea rths a threa d o hearts u s heart

he r eath u n ear thed a hat e wi haet

she h eat s a n ave s o vea wil l eav

me f ea we r eave wi v ea you r eaf

f or eau sa w eaves a fea t o f eak

her e afs a safe so f eague the fake s

she flea s a fe al else fl ea t is eafed

the fales i lea f are f alse so f ea red

he leafs a fare wi f ar se he re f ear

the far es a lea fed u fea re de f eat

she f ears a r ate me f eats er fat es

the f east o fe aze re f lame me flea m

the f lead h i feared a flea k en e flames

she f lare s a flame d in eak s u f lear

hence f rea were f lared a s eal i fre aked

don eal s a g ea l i gael are g ales

the gaels a r age de g ale re g eals

me glea wi g eale d are a ne t o gean

ye gea we re gane wi g ea n or e an

you r ange ti s arge so g rea do g ear

the sarge we re g are wi ra ge me g ears

he r age d en eam s a g arse wa glead

re d eam ed a glade that ea ne d are gleams

he glean s e g rease so g leane me g real

the gr ease d are gr eat ere targe re g rates

the gre at s were g rate to grea ve me haem

the g reaves are hame fo r ea d are he ad

he heads a ha de d o sh ade the s head

the heal s i s ad e we hale be hea led

57

 he r eal i s ea sh u lea shed a hales
 hi s ale s un eal d a le ash in ealth
 he sh ale s a heal as ea p a he ald
 the hean e y ap es a hea wi he a lth
 so sh a sh ape d up a heap ure hear n
 she heap s a sh ape me h are do hea r
 the rhea wa s ea rn i h ear ne wa heaped
 he r ear sh ares on else hears are s he ared
 she hare s a s hared ere hear k en ear k
 his ea rse has are d a sh are wi sh ear
 he shares a hear se t o hear th u s hears
 she h eat s a shar as aste ti s ea thed
 he hear ths a ha ste wi h ates e heat hs
 de jea wa s ea ve to heau me me h eav
 jea n eave s a s heave we jea r are kean
 ye je are me j eate so jeans a s he aves
 the kea were k ane to k eane s a ke arn
 she k ne ads irc kale wi le ak u k nead
 he l eaks ure s lake fo r akes ere le aked
 the lake do slake ye r ea c ale l each
 me l akes are slake d a lea we l eag ues
the l each i s ea gued erse lea l i l eam
 de m ale were la me wi m eal a n ames
 he meal s a m ales a s eals are l ames
 nea l anes a nale so l ane we re l ean
 he l ane s a l aen ere sla ne do le ans
 neal s ean t is arle fo r ear ls a lears
 the lea r i le ant u lear n ere l eased
 the re al i s ea rl i f ar les ire learned
 she l earns e lea se to lare me l ears
 the t ale wa l ate wi le at erse l eaves
 me t ales are rale do le ave ti s leaved
 maeve leav a me ad a s ames a meak
 she d ames a ma ke wi ka me t o leaved
the dame ma de d o so s leave re m akes

 58

her e an are mea n in ane s u m anes
the n ame wi m ane mean s anse to m each
me m anse saw ame d are m ea were nam ed
he n ames a n ame where chea m ure m ear
he r ares are rea m ere ram e were me ars
the la m are reams a s mea w i s mears
his a res are r eame d o r eam a smear
so me a were mares a s ea th is s meared
the m ate we mea t are meant u s t eam
ye t ame s are t eam a s eats are mates
he m eats a tame wi st eam s up ea w
de tea ms are nea f or eat hs a m eaul
so me a th i s ane ma m ea re meaw
the m eawle wer eaw u fa ne to n eaf
me n eap o na pe w as ean are p ean
we neap s a p a ne t hen anes a napes
de sna we sna pe t o s pane me s neap
she p anes a sn e hence s nea wi pe al
the lea ti s ea ps erse p lea were l eap
he peal s a p ale then ea s ure p ales
the lapse re leaps a sla pe w er e p leas
she pealed a spa le t o p ea me l apsed
he r ape wa leape d as ape s ire p eas
there spa w is ape d in eace wi n e at
the peace wa s ea ke so p ea ch a c heap
the pea ke ti s ea ks ere peaks ure s peak
hence s pake to p earl as arle wa s ear t
pearl s ate sa w as t else parle we p eart
she s peak s a p ease me p ate re peat
he r ates are spea do t a pe to p eats
he t apes a spa te ye n ow erse paste s
reds as te we phreak i f ead s i p leach
she plead s u ple so p lease d are ple at
he plate s a p lea se where prea to p leats
de p late we p reace me quea n i pre ached

59

we re a d e ra che w i chare to reach

red s in we re alm a s ea p a reaks

he rake s an e alm ere rea p e p ear

she chare s a p are to p rea d o reaps

the ra pe w a prae so re a wa r eached

he pare s a p ears ere rape s ure s pear

the s pare ye p arse d are prase wi p ared

me dra pe w ere raped a peare d i re aped

he drapes a spa red e parse d a s p read

the r are were r ear if eas are sch me ar

she reare d in eave to r ea ve me s ea

the sae wa s ales e rse se as wi se al

he r ears a schme ye sal se w e seals

their sale s a la se t o sale the se aled

me se ams erse s ame for o s hea n eas

sea n anes an a she w i nase hi s eans

me sea rle re seam u sa ne we se aux

de seau ye seam e d a s nca their sh eaf

the sh aef er eafe d are sh eaf s er leafed

he s heaths a sh mea w i sh mear u skean

the kean s a s nea hence snake wa s meat h

his eake d are sneak as ere sn eat he s naked

she snake s a spear e so s par es are sne aks

he r eads e sparse here s preag h ere s pears

he s p ear ed a quea do sp rea we squea l

me squea m i st rea wi swea t he n astes

she s p reads a swe at er aste to s queak

kate s at es a tawse re st ream in was tes

she teak s a t ake were sk ate to st akes

me kea to s keat i sta ke w i st eaks

the keat s i s ake d e stea wa s kates

he st eak a stea n are stake d u st eark

the strea we st real e so tea r a st reaks

me t e ars i rat e sa w its are tares

we s t are wi trea so t are me rat es

 my eas are s late to sl eat a star e d
 me st are s a t ate so slates are l east
 he steal s a s tale when eal th i s eat
 she tales a n eat s ere steal t h is east
 ma t eague wi t ea tis ae l or e ased
 the sate were s eats if ae t are t ease d
 he teaed u p ea gue ye s ate s are laet
 me t ale were late wi t ae l ure te al
 the tate to t ea t are st ate ye t eats
 the tat e s i n eap e sta the s tat e s
 we hea wi re a v a t heave to th reap
 the tat i s ave so th r eave we thre at
 me t rea sa w eak are tra de re t read
 he trade s i t reague wi t reads e tr eats
 the t weak e d are twea so lave wa ve al
 she v eals a sal ve do v alse me v ales
 the sla w ere salve s else va les e slav ed
 we salves a slave t hen a we b e sal ved
 t he w ake he s laves i weak u we al
 the wake d are w ale wi wea ye s we al
 she weals a wa k erse s wale to w ales
 whence w ea ld a dwale we weam e w ealth
 the weal s ure w ame so w ane ma w ean
 you r eal ds are waned a s eans ire we ans
 she w ealds a wea r else wa re b e wanes
 ye w ared ere w arse wi wea v are war es
 me w eaves i w eaz ere w heal e s wears
 my eathe ti s ea ved a w rake to w heat
 he w reak s an aye wi wreat h a y eah
 you r ay es o yea f or ay re we yealm
 red ayres are y are where y ean a y ea r
 hence y earns an ate s a y ears e y east
 the yeats ire y e arne d if aze do ze al
 where y ates a zea wi l aze da b e ad
 we y ear n a b ane wi bad e do b eads

me b ake ti bea k a b ale wi b eal

 her alb u be w e re b eaks erse ba kes

 he b eaked an albe wa b ale s eal e beam

 me bea wa s ale d are b aked an eans

 she bale d a b eale wi beam s its ared

 the ban e wa beame d a b are to b ear

 me beans a bra e so b ares a re b ears

 the beat s ire b ared ere b ate re b easts

 for aste me bas te to b ear d a b read

 the bates i s ear d a b astes are b east

 he beards a n eat h u beau we b read th

 s he b read s or eaux a beaune to beat h

me beaux a re b lae so b leak ire be aut

 the b lake tis are d i f ate do b lared

 he bl eat s a le a wi b lear is eached

 me b late were brea fo r ake de b rea ch

 she breaks a n ame so b rame we b ream

 he r ace break s in else brakes a r ake d

 me cea wa s ear e ye br easts a bra ked

 he c eased a n eare to c hear e de c heats

 she teache d a t ache we cleac h i c lead

 ye cleam u p ea ned a c leanse do cle ar

 clare c lears a cl eat u cl ea wi c leaves

 re d ares a c leared ire c lea her e c leat

 the clares a c reach a cre agh u c leave d

 he c reaks a creagh t i c rake were s creak

 the s c ream is eave f or eame d are de ad

the da de were crea me d i f ade do d eaf

he c reams a fad e here de a to d eal s

 he r eams e lade me s cre am s a le ad

 he l ead s a d ale to lade s hence dales

 the slade ti s ea lt a s ales are s lead

 ye deale d a d ealt else dan e the de an

 me d eans a b rake wi s ande re s nead

 those d anes are snea wi de a we r ead

me dare to re a d a d rea were dear n

ye dared a d ear th as ea th are th read

he th read s a death ere d earths u d read

he r ear t is arme whe n ea m else d erth

me drea m a rmed in else d eave wi d reads

she dream s an e ame d if erth are m eard

me d rear its eig h as eigne we d eat hs

i d rea m or eigh t as eine wa s death

di s il d is ein ers e fie will eil d

his i fe w ere sli so fife wi de il

de l ife tis ils a fi le w ill if es

he f ile s a fiel erse fie rce re l ief

she l ifes an iel d el se frei were fie lds

me s life tis ei r if eine wa fr eight

the frie be f ri ends an eis t a g ein

her en gi ne g eine was ei t u g eir

the geis t is eithe w hen eige sa g rief

me grief s a g leir i greige wi g rieve d

we gri e v a g reithe for eize wa g rieced

you r ights are hei wit h eil d a h eigh

t heir eize wa hile the n ie d erse heil d

though he irs a h eize wi l ei to l ied

thence l ie t is eif ile kei were ke if

the kl ein is ie l or e ighs are klei g

she pile d a lei ma p ile wi s pie l

he piles a s lip e do s pile ne m ies

we n eig h its eik h a l iege so sheikh

ye p ies in lieu f or it s a p ieced

me pie wi p ei se w ere pied u p lies

the pier ce wa si pe t o piece de p ies

he pri ests a sp rite so re ichs are r eign

she sprite s a p riest ere seine be s ieg ed

he r iste were se ise hence s ite their tie s

me s ites u sieve e sl eight s ite speight

though eige were sieved an eig or ight

part five

your eise we re t ied a stieg o r ein d

 the s tei n er ierce wa s ei v a t eind

 me t ei se wa t ierce to ve il a l eiv

 so t hie wa s eiv if eils ar e t hi efs

 we t wie the vile t o l ive whe r ive s

 ye s live wa s iv a vlei re v ei l ed

 he l ive s an ei g or iel d ar e ighed

 re d ile d u live d as ield s an e igh

 she v eil s a w ie so y ields w ent ein

 me w eight e w iel d a rie wi b eil d

 so b ein uare bei ge ma b rie wa brie f

 the bri efs ar ief s i f ewe wile d ie fed

 me brieve wil l ei s h a chie f e d eign

 he d eigns erse c ries h as ein t are s deign

your el a r elg s a n it s a d reigh

t he gel o n elt is el t ire le g

 ye l eg s ef t elts erse lef t i f elt

 he l egg e d it eld u le f are f leck

 ne d on e tel els t a le st u s elt

 he l ets an el c u f lects a re f ledged

 the fleg m i f letc h ire le lc o f leur

 she gel d ure g led ere gle w i g l ent

 the g leb e wa g el t ur eg e g let

 me g le wi he ld ere h elm s i k eld

 mine k elp ure ke lt as e le d o pelk

 there skelt on elc h a s kel p u c h el

 the le ched a kre le wi le de no l em

here me ls in e lms on el m erse le dged

the n els on end s an engt h a s lent

le n els a len g a s el ds a re l engths

 le s elns a sle w i le n t e l etch

 he le tched a sel i f ew d are w eld

 s he s melt i le wt h e lew d u melts

 he r epts u p elts are slep t i s m elts

 bu t eb s a p ledge wi p lebs e s pelt

he p l ed ge d an el p u s le wi quelch
there sel p a sled s i s lew er se s ley
we s ledge to w ells a s u wa s le ws
me w elts are s welt it el p ure s wel p
the t we lfth e v elde so w elk s an els
their elve t is el k ens elp s ire t w elves
the wels h are wel t or e lme wa w he lks
me yeld ore w helm ed a yel k i nes el ch
red elp e d are yelm i ye lt elves el ched
your elts ore y elpe d u b le we re b elts
hence belche d a b le b ere ble b are b led
where bl ere sa w its a b lenc h i b lent
she b lew a bles t erse ble t ure l ect
the c elts o cle f u c le m e c left
i cl en ch a cle wi c letc h u c leugh
the cle w is e lc ire d elt are c le uch
here w elc ore le w u t el d in elv es
yours el c an el t are d elv e d in ees
me bee wil l ee l a n ee c o l ees
lee me s a s ele wi le s e to s eel
she lee s an e els a s ee m i s een
fo r else will ene to m e e wi fe es
she feef s an e ed i nee we re f eer
he f rees a re ef e re f eere wa f eet
me fe ers are free to f e te d e reefs
so flee wi flee d if ee ce were f etes
he fleece d a f leer a s ee g are flee t
she fle ets a free b u g ee be g eer
de gere ti s ee st i gee se w ere geet
t he g eez e glee s a g eeze wi g leek
me g lee we re g lee n if ee t a greed
the greek s a g ree f or ee ns else g green
the gree ne wa g rene to g reen s u greet
his e te r e gret e do g reeve wi g reets
s he gre eves a hee d u he de d o heeds

67

 the h ee l u he le wi he e p o h eer

 hi s ee p e heeps a h eez u hee l ed

 he r eeze sa w ee d i je e fo r e eps

 so s hee p are hee ze wi j ee d an eers

 she jeep s it s ee z else jeer s u jeez

 you r e ere ti s eek as e ke w a jeered

youre j hee l a c heke for ekes a re k eech

the kee ti c heeke d o ke e fe w i keek

 his e le w ere kee l u k ele me l eek

 the klee ti s ee l ire l eek s are ske el

 so k lees are keels i f ee ks are s leek ed

 he sleek s a s leeze wi k eele d i ke en

 we kee p a p eke to ke ens er se p eeks

 the spe ke w a peek as el ne w a ne el

 his ee le here ke eve so n ee sh e k nees

 he knee led a kwee fo r ee f are k week

 t heir l eeche d u leef if e le w a feel

 she f eels a lee p ure p ee l i sle eps

 me slee we spe le wi sp lee to p ee ls

 wee leer a re els ere l ere wa le e red

 the ree l eese r eel as e rse we le et

he re ele d an eese wit h e do me er

the me ek i mere t ha t erm e me re em

 we mere s a m eese wi m ere d i m ersed

 there m eer a m erse so me ere wa m eet

 she m eets a m ete ye t ee m ere ste em

 their en es a re m este yu tee ms i d enes

 me need i s een er em er ne t ee me d

 me n eeds a re p een ure nee p i n eer

 her pee s ee d in a dee p ee s eep ed

 me pe e ne eze see p e pee d o n eels

 the peel a s lee p are seep s an e el ed

 hi s ee nge wi pe e p its ee p ere peer

 he peep s a p eenge so p re e were ree p

the spee r i p eer s else spree w a p eere d

68

me n ee wa s it s a ne ep erse p een

my eers ere s pre di p e rse wi sp rees

me spee we re n o w i sp ere y our eeps

their eer i s ee ve w he p eeve was eve d

he r eeves are p eeved e re p hee we p heer

then eeve d u phee ze d o p lee to p leep

s he p reen s an e ened e que ens e c heer

the queen is e ers erse se re d o se er

ma q uee ra re e ch a cheer s ure re es

we s ee an ees t ere s ees are see r ed

s he seer s in el se were st ee do re est

the stee r a t erse so s teer s u re eked

hi s eer e wa s eer ed as eke wa st eer

he re eks ure ree ve f or ee f are re eves

whence scre e he r ee wi cree to sc reef

she ree ked a s creeve wi scree l a n e eds

the seeds a re d ee s i f ee ge were seeks

her eeke d are see d a s eege wi se ek

the m ees are m ese so see m u se eke d

t heir eems are se me w ith eeme d e s ees

the s mee se ems es e ye r e n se were seen

red ens a sene seeme d it s ee t ar e es

the n ese see t ee ts if eet he wa s eethed

d an eethed a seet he w i sh ee to sh eel

the tee s is ee the d a s eens are she en

me sh eens are shee r u shee s h i s keet

he s eethes a sk ree so skree k are sk reel

she sleet s a s cree n ere s leeve do sk reen

the sleek h are s lee t e smee ch u s meek

we s nee whe smee t h ar e spee to d eep s

the spee d are snee r a n ee d er e spleen

ye s nee r a pede so le ste we re st eeds

lee plees a sple e wi s t ee k o ste el

he st eels a ste le s o steele d are st een

the te ens are n eet a s een th i s teep

their ee v i ne te wi te ne t o st eenth

 stee ve st reets an ee stee pe d u st reel

 we swee p its es te w her eet h are swee t

 ye w eeps a sw ee wh e t ee d o t eers

 t he w ee we rete were tee s i t e eth

 he sweet s a w ee p e re t hete teed up

 m y e e r a t hee wi t eethe so t heed

 me t eethed an ee d or et he w a t hreep

 we t hre e we re rethe whe n ew te be weet

 she three s i t ree wi t wee k else tr een

 the t wee ds a twee w he n e w e tweel

 ma ve e wa s ee re d i f ees there treed

her ew or ee t ure t weeze be t w ee n

you r ew e veen as ede s u re v een

me t weets i vee p or e eze wi v eers

the swe de w a wees u swe e t o w eeds

 here week s a w ee l ers e swede s aw eens

 there week i s ee n ed ere wee m are we en

 we wee p it s els e thence w ree w ere w eer

 she w eepe d a n ee ze to w eev a wheech

 me w eeze do w hee ye w he ek e w heel

 t he w heen i s eep a s ee ched ire wheep

 he beeche d ere y ee p o r e ef e the beebs

 hence beef s u p ee le t o ze e me b ee p

 here beefe d a b een u b eele we feeb

 me bee r i b ere w here bree beet s it

re d eers a bees t i be et h o b eeves

he ble eds a bhee l if e e d are bleep

we b reech a b lee the n ed e wa b reed

 red s ee ds a brede so c hee wer e s peech

 me c heep s are bre ek u chee no w ee sed

 the cheese w a cheere d a ch eep s i c leed

 me clee de cre e ye cle ve t o che eped

 we cere d a c leek erse c ree s are c leves

 the cree d i s eed a s eep a s c reeds

70

he creek s it s ees h u creel a re c reeps

we cre esh a cre eve f or ede re d e em

dee d eem s a d ed e so d eeds ar eem

she d eer s a me ed u de me w i smee d

ma m ede mined er d ire d ree to d rced

your erde de re de w e re d ere the re ed

she r eed s a d we then ee b are d reep

bu t a fs are d wee to f age me ca f

we f ac erse d weeb as af s ar e ha f

he f ace d a f a h e fal me w i fahr

the fac e re f ames an af t u f am p

here fat erse s ta f a f as t ere f ats

he fast s a f a ve t o f eme the fed

she fed s a de f i f egs a re f ehm

ye feg s e n ef as en ore f en ced

the fen s a fe rme w i fe nt u fest

here f ew te w e fi b u f ice to f ig

there fibs a r ib be d a gi f i f ilm

the filt h i s il me d a f il ore figs

thei r in d a fib be d a g if u find

ye fil ms a f ine d u n e if i nief

were re f ine n ife to f ip a p if

you fir a ri f e re f ir s ure fr is

me f irm s u fi t he fis h e f im

he fishe d a f is o r ift s ire s ift

she f its a shi f i f it s ure f ist

the fr im e fi st s a fri wa s ifts

me fla w ere la f a fl adge wi f al

he f lans e flat s u fl ate de f lints

she f lirts a f li te d o flo n are flit s

he r its else flon g ure f lo d o f lop

here flo te wi flu b e flu s are f ob s

where bo f i f odge wi f oh n o f ond

the fon t a n ow are fo ne me f or

he for m at o rms a four be t o f op

71

the f owl es do b e wi foy e f rancs

fra n or f i n ow f else frap are f rayn

she fr ends a fre re so f res h u f ret

the freu d is orfe d if ow fe d a t ref

he frig s a f right ere fri t e f ring ed

the r ift i s ig ged a s ifts are fir st

she ri fts a fris t u f irst s ire f rons

we fu d i f roug h ere du f a re ful

he g r afts a fu m o m uf u f usc

i haft s a sh aft u h eft s e k left

so s haf ts are laft e hef t i n af t

we l ift a laft a s if t ers e f alt

her s lif t en of t are lif t s i f ilt

the to f else l of t ire h ifts ere s mift

he shift s u snif t e r ife wa st rift

she thef ts a stri fe w i t ift o t oft

you r uf t i waft a we f t are yu ft

the b af t a t uft ire daf t are k alf

so ke f are ker f an uf t o k reef

the c ruft s i k if are lif u m if

your inf ore ni f a f in i s o af

me f oa we re f ou to p elf a pre f

red s ouf i s urf as efs a re f ers

the refs a rol f e sau f a sc ur f

me roa f are se if a s ke w i se rfs

we ser f are s k el f as arf ire so lf

she surfe d a s nar f if o of u f lus

he w harfs i sul f a t ief er se t ruf

the s woo f are zar f as auf is o o fed

here w o of er alf a boeu f ere b rie

de b riefs an afe d if el f are cal fed

my el fs e brief s a b umf u c hafe d

de c hef s are cau f o cl of a s elf

we fe l a l ef els e fle w i se lfs

the n a lf ulf s i n a g nof i half

72

the gul f i f a wa f affe d e n uff

he f eoffs a faf f or af fs e re f luff

me f lu w ere feff a s af fe wi f uff

so g eoff is affe d a g lif f o g aff

the gof f o g raf f a re g rif f in uffs

we gruff an uffe d i g uff u ho w ff

he huff s a n uf fe fo r if f are jaff

jef f it s are j iff in of f er s if fs

ye kiff else lif f ire l of f an if fed

de m if fe d are luf f u miff e m uffed

he r uff s i f aff uffed o uf f are muffs

she p ouffes an ouf fe wi naf f o p aff

red ou f fe d are pif f ere ffe to p luffs

he puff s up uif f ou r uff s in uif fed

me quiff s a n if f i quaffe d o ra ff

he r iffs are ruf f e r af fe wa r iffed

she r uffs a scaff o r if fe w a s offs

me c af f in offe d a s chroff u s claff

the s cruffs a r uf f u s hruff i sc offs

weve s kiffe d an of f u n iffe wi sk off

you r if fes u slo ff as owf f are s niffe d

me snif fe w ere snof f e r iffs are sn uffs

he sn uffe d it s ow ff else spiff a sp liff

she st affs a sow ff ere stif f e n uf fs

hence taf f i st uffe d an ef f i t eff

the t of f is af f ere s uff e rs iffs

here tiff s a t reff ere t ruf f i t uff

she tuff s a n off er af f i n o uff

ma v iff o waf f e n uf f e whiff ed

the w olff is af fe f o r uff a w huff

he b iff s a w uff ire yaf f ure zif fed

t hei r if fe wa biffe to bluf f a b off

thei r uffs u bou f fe w i buff e r ef fs

so c aff ine b uffs ure cha f f or af fed

we chaf fe d a n affe fo r iffs are chuf fs

cliff uff ed a clof f u c off e c ruff
here c uff s an if f if uf f i s cuff
hi s uf fe w e d aff as eff is of f
the diff is eff s i n an ge so d offs
he diff s a d of fe so draf f erse en g
there duf f i g al u g albe were g alp
hi s age d are gal t a g ange wa g aoled
he r age do g a s o g ate s ure goals
me g at is engs a s t ag e to g ault
so me g a gem s ore ge ne w i g ed
the gen e r e g a g e nu g ent
me n e g a g erms o gene s u g ens
george get s a g re m i g est e r est
we gest s a t eg u g ha hen ce g han
the ges te w i han g a g ha p i g hast
he r an g e gha we g hee wi g host
me ghi will ib b u g ho le t o g houl
the gibb o n ib e s a g houls i m ig
he gibe d i g il d u g lid erse g ilds
she gilt s a l ige wi g ile to g lt
her e gil s ure gim as im p s o n igs
the gim p i gi s o g ir are tig
you mi g it irt h ere girt h a g is
si g it s are g ise wi g ist u s tig
ma g it e l ang are tig s i g lands
he git s a g lace wi g i te d o slang
de gla m u t ige were gle de w i g lans
she glimpse d a g lint s u glis t el se g lob
w here b olg e glo de me gloir e y ou glom
so gnas h a sh ang o r uck e the g luck
you r an g erse gna to t ang a g ant
re ds ugs a gne w i n un g u n ug
he gnome s a g nu wi g u n ure g oes
me g o le her e loge so go m a re mog
there s mo w a s mog i g o me wi gorm

74

his o ge we go ne t o gor an or g

the m org a n og s a g rom it s og

where hog s a g os i so g u g osh

she go t a sh o g u t og s u re stog

were to g a go te me g ourde wit h eg

we goy le d e grade ma g ar de w i grec

de g re wa g rece so gre ge t he g reggs

you r eg e re greu wi g reun d e g rew

t he grie g i g u were guc k a g rim

we g ri lse d a g rime so g ril er egs

the g rim m s a g ri wi g rimes e g rind

she gripes a g rip h i gr on te w i grum

the gris i s e dge d er s un ge wer urg

me gru wa g ui the n ed ge do g uimp

he hedge d i g run ge so g un ge we guil

the hen ge t i s in ged are huge de l ight

here hinge wi ked ge so l ight s i n od ged

there lodge d ire lon ge t o l onged a l ung

though ung s ure l unge wi m age re m eng

whence m adge sa w an ge for erge wa s igh

she game d a m ange the m inge re m erg ed

he r udge wa s ight a mongs t ure p hleg m

he n ights a nudge d else p igh t i t oughed

his un ge wa pla ge w i p inge ye p lights

de plough s i po dge f or on ge me p lunged

the ponge s is udge fo r id ge d are sponge d

her ight s i n id ge n ow udge do r ights

me p udge were quaig h el se r idge wa s right

reds ouge wi ro ug e were ruge where s edge d

where s crin ge to s crouge we scunge ye r oun g

here se rge wa s in ge whence s ights are sing ed

the singe sa w in gh o res ing e though s lights

the s lu w ere sn urge wher ur g are sludge d

there s plu to s p lunge wi smu we s mud ged

me s nudge ti s od i mudge were s p lodged

75

we sp lur ge me s prenge fo r en gths are spl urged

ye s punge the squdg e so s tinge were st ren gth

you r od ge wa s todge we s wadge re sur ged

the stor ge t is ighs u s w age were t highs

here s wed ge do t enge for t hi be t ights

we t inge de thigh t u t win ge d an ugh

di s urge were grue to v edg e me w edge d

their in ge er se w enge cos ilge wa w hinged

the w right i s il ge wi wigh t a n igh

he b inge d a b ilge we b lunge to bli ght

she bodged a n on g er ud ge d a bon g

the brigh t on urg h e re b udge we b urgh

the c age wa c haun g u cleg a re c onged

hi s aw d are c ringe d if awg ore dodged

me daw g o g aw d are d odge wi d ight

ye dredge ma d og e wi dron g i d roog

her edge wa drudge d i f an ge d a f leg

where fad ge t i s edge d else fights a flan

their oge we r ang e d u g oe to f lights

me foge wi f udge ca n a g a g ag ged

you r ang e ga g ifts igg s i g ang ed

he g igs a n ift a s ing e re g igged

the gigg s ing s o n ore gin s a n ig

the si g n is ig s i s nig e r ig ned

me sin g a s igne d are ging e re s igns

thei r an ced a go g erse gong ed u sin gs

my eg are g lance d else g la w i g reg

de g rice wer e g regs i f og are g rig

he hangs an u g u sh a to s hang

me hin g it s ogs i ho gs a re han g

the hog g i s ong ed a hon g i hu g

the gog h e r ug ge d are hung a n ag

hi s ag s igge j ag a s ag g erse jigs

the jags are je g i f ig else ji g ged

red s ogs are jo gge d a t og i s ong

he keg s a j ong i kag g ar e k rang

she king s a s keg o r ag gs e k lang

the g ink is u gg a s ag erse k inge d

here k long a k nag a r ing i k ren g

there k rug e gur k are lan g it s ings

where l ing are l onge d as ugs a re l ug

you gu l a l ugs i f ug ge d ire slugs

she s lug ged an un g ere m ung o lungs

red ag ge d a nag i f an g ire s nagged

my ag ge be g a n an a gg ure s ang

we nagg s in on g e r og g ore sna gs

ye n an g a n og i ned oun g are gon

we pan g a g na p i p angs u s pang

so p egs i s ing ed i f egs a ping ed

she p ong s a p ling e s pon g e pon

the p reg u pro g i s ong ed ere p rongs

here p ronged a gro p i s pro to p ron

the pu g in er s a g u p ore p ung

where pug s e q ua g ire ren g a g ir

t here r igs ure rin g ire g irn e r ig

me ring s a g rins u rigge d ar in ged

the de ga s ag ged erse ron g a s ag s

he s ags a sca g ire g as c o ns ug

we scu g it s ing u sh ing i sh rag

the se gs are ge s u r an g e skag

here l ings a n un g i s lang a s lings

he g uns are snu g a s ongs ure s or g

de gors a rent un gs i f or gs are sp rung

me t ings a s tin g i st rin er inged

ye s tings a stun g a s ing e r e sug

so g us i sug g ere s wing s a t ag

he tag s a g a t els e gats i s tag

there stag s ure g ast i f ags a re t ag

we t han g a thing i t hong o th ring

we t hu gs a n ut h are tin g a guth

de g rits are ton g i f it s a t rig
me gir t o n an gs a gris t i t ung
he t w angs a stri g a s igs e twig ged
she t wig s a w aged u n anged e t wan
me w ag e ti w higs erse hang u w han g
you r igs are whin ged a g i we re w igs
we s wig s a wig a s in ge wa s wigged
ye s wing a w in ged i w rang erse rin g
you w ring ed a y egg els e zug is agg
f or alg e r ing e d a g uz are lagged
he g als a lags a s ag s are s lagge d
the re g al ang s a g la wi s la gs
he b angs u sla w e b eg a s lag
she beg s i n an ge d or egs ere b reb
t he b er g its ange wi gre b i b ig
the b ergs o n ag a gi b u b ing
so b ings are blo g i g ib s o n og
we b iggs a blin g e re b ogs are g ob
ye b log gs a go t o gob s un og g
hence bo g is ogg s i f ig a re b logs
de b og ge d are bri g an d igs an igg
here brig gs are b ring s a s ung ed are cag
the cha g al ls ugs a n un ge wi bun ged
there c hug an ugge tha t ang s i c lag
she cl ang e d in u g or og are clin gs
reds olg a c log s ure c olg a r ol gs
we c lung a c log i d ang e g and
the di gs ere cog s i f og are g id
he d ogs a n o d ers e dig ure g ods
the be d og ong s a d o mi d ongs
me gon d a d regs a re d re wi d reng
hence d rug s a d ug i g er it h eg gs
where d wang s an e r g o n ags i ger
here re g i fag s or e rse gre fan g ed
de flags ar ag e d as el se w ere flan g

78

 he f legg s a f ling e re f logs a r olf

 where g olfe d a flo g i f og or o gs

 me f og i go lfs or og wa f log ged

 we fo gs a ha c as ogge d are ha g

 ye s a h ere ha h are ga h ire hak h

 he has a hal k e wi halg h e h alm

the hals i s an se so h al p are han

 he halt s a n ah e han se wi hanced

 so sha ne w a han ds as a ns a s hand

 the n as he w ere h ans a h at i has t

 there h ats a s ha t u hau to t ash

 his e h are he be wi heh a h em

 here s he m is e hed a h em e fo r esh

 the he n i n e sh a ne h ure n eshed

 s he h ems a he nce wi s he n u me sh

 herb s erds are h end u s he wi sh e rb

 he hen s a sh erb s ere h erds are s herd

 we h erm a h er ne where he m u her p

 so h erts erse her te w ere h e st are het

her et h er he te w a h ewe to hew gh

she hew t a t he w a s ig h ire hic

me hi g are hig h i f igh t a r igh

 the hil t o n ights a hig h i l ith

 we h ilt s a hig ht u h im e h in

 the s hil t o hil a ni h ure h ein

 he hint s a hin de wi p hi t o hip

 ye h ine re h ip e so h ir are h is

 you hish a h i t ire t hi here h is t

 he r it h are hit s a sh i where s hit

 me s h its a stith e shit e wa s it s

 de s hit es are hod e lse ho e ho c us

 here hoe s a sh o wi hod ge t o he ists

 there sho ed a h o wh er e hei du m oh

 red s oh m u m ho whe n o me we hom

the hon d a h one were sho wi h on

part six

we honed a sh one wi h on t a ho nes
the poe s a n ot h e re hop ure h opt
he h op s i ho pe s a h osk u ho ped
ye h o te t he hou d i hul e to h us
you hat h a n it he so kit h a t hal
the lat h am it h a hit he w i l athes
he m ath s a kit he we l ethe do me it h
the lit he w ere luth e re m eit h a meth
here meths a t he m a s on ths ire m oth s
where tho m a m onths a n o r th o nin th
there t horn s i n orth if int h are thron
s he n orth s u p ath else per th i s path
he p aths an ert h or e t he t he p lath
mine pa th an o uth i quet he w i r outh
reds art h are the w e ythe w a s eth s
he scyt h es a sc out h if es th i sheth
the se th is ait h u s it h ire s k aith
thi s it h i s ith e we s lat h in cuth
you ll it he w e slit h i s lue for e uth
s he sle uth s an uth i f owl t h a slith
whe r oth e rs out h a n ouw th ure slo th
we s lout h a s mit h a m at h i sowlth
here s mit hs a nat h u snathe do s ow th
your ar th u s part h as arths a n il th
di p at he will euth i f ew t h are s pilth
ye s pathe re st re uth a sty the we r ewth
he r strew th is an th e m ath es ire thack
your at he wa tha fo r at h el se s wat hes
the t hame s a tha me t o n athe me t han
that ert h is at he so t han e were t hat ched
here t hanes a thebe s a t hei ne w i th eir
hence t hei n u t heir n i t he wa t hem
her erth i s t heo w o t her in ert hs
where he we t he rm s i t hese to t he sp
we t hewe d a t he y e t hicks are thil k

thin e t hole wer irs t a t hor pe me th ow

he thirst s a t hi s u th rene t ho t hrew

those th r ice we t h rift e thos i th rum

where thud s a t hu wi t hule we t hum b

her it he w a tha w erse t hu were t hump ed

hence sut h ere thu m are t haw ire t it hed

me th wai t is armt h u t hwai te we v eth

ye t h wi re thwite so thwi t o w arm th

were wit h i n id ths a rit h ere w id ths

you wr it he d a zit h as auth o r at hes

here bathes a n at h if ert h a bat he d

hence b erth a bath s it s et h e b eth

s he b irths a n ot h ere b lithe wi t heb

where bot h a re b ro w i b roths erse th robs

t hence cat h ot hs an o r ot hes a c loth

she c lot he s a c oth a s out h i d routh

me cout he were fla it h if ul th i s un th

we f outh e fulth i f ee nt h are g rout h

ye green th a n eigt h as eit h er ai ths

he f aith s a n ift h a ferth el s ift hs

she fifths a fir th i f or th s a re f rith

t he fo to f ro we re f rothe d a forth

he r aids are f rot h s a g it h u g oth

here d ai go th s aid e re dai s i ail

my ai k en aik s are l ai h ence s a id

their ails i lais i f ai l e d are sail s

he s ail ed an aim o r ain t arent a ir

you r ai ms ai re d on as a ire wer airt

wher ai s is a isle mine r ai tis a it

hi s ait ch a t ai so t hai wa s aith

here b ail s an ai b ire b a in and aird

the bair d in ai b a re b ai le t o bairn

their airn s ore b ait s a b lai wi b lain

the b lair we re b rai so b rail e w a braid

his ains are b rai n e d as aise were br air d

he b rain s a c ai wi b ra ise d o c aid

the c aik ure c ain i c aique wi c air

me c aird a cair n if aise d a re c hain ed

she chain s a ch ais e so c lai we re c laik

her ai c re cl aim s are c raic ire d ain

the claime d a re d aint e fai we d rain

ye drain s a f ai le t o f ain a f aint

you faint s a f airs i f aith s ure fail

ye faith s u fl aile w e f lair e wi f lail

we flail e d a f lai r as aire we f rail

the f lai wa f ail s i fl ails e rse fla irs

so f lair e wi f rai were frai se t o g ail

me g ai wi g ai le d o g ains a g ait

the tai g i g a in e d if aigs u gla ik

we g lair its ai ve t o g rai n e g rail

re g laive were g rai ne d as ai p a hain

di g rai p is aic k i g rait h ure h aick

the haik are hails o r ail s e w i s hail

we hai ls e m e h a int ere h airs are hait

she ha ire d a hait h a s ail e ti jain

he jail s a k ail i f ai n ers e l aik

de k aims o kain a re k rai t i l aic

hence l ai ch el se lai d er e lai the dai l

the l ain a re l aig h where nai wi n ails

reds aigh e s nail s i f ail e ti s lain

she r ail s a l air s ire mai we r ail ed

the m aids a lait he to m ai l a m aim

thei r ain s e m ains ar a ire re m aint

ye r aic a mai re w her aice ma n aik

mine nair ure n aice wi n ai he n air

your ait ire nai t or ai p are p a ined

me pai were spai so p ain s ure s p ain

the pai ne p ail s o n a p aik i p aints

here pa ir s an aire wi re pai p ai red

he r aice wi p laice were p lai r e p laid s

84

he p lain s a p laint erse p rais e w as aich
the quail ar e quai to q uai le m e r aid
dee quaic h i d rai do quail s a s quai l
s he r aids a quain t ure d rai to r aik
their air n are rain i f air n el se n air
whence r ains a r aise d as ai g o s aic
t hei r ais on ait he w here sai d o s ais
these sai t are sait he d i f aints a sa int
here s ain ts are s cai f or ai f its aich
your aife we sca if e to sc rai wi s cr aich
tho s mai m a smaik u snait h a sp rain
so ne d ere spr ain s are s prai we st aid
t he s tai we s taine d as ait he wa s tairs
we st ai le d e strai n o st raithe can aif
she s train s aine s traif if aisc h erse st r aik
the tai ne t i s ail u t aisch r t ain t
dee t ail s are t ais h as aits er se t raik
erse trai we t raile d a s trai t u t raits
where r ai t s e v ai wi v aik a va il
we v ai m an aifs i vai r a w ail ed
the v ain are wai no w ai f ai n e w ains
me s wai wer ais t o w ain e the s wain
his aist s a w ais t as ai ve wi waits
w here w ai s a w aived u wai to w ait
he r aiz e rs i d are w rai th in ides
so d i were zai wiz ai m ire d ie s
red s ide we zai m in e id e side
we d ie to m a iz e s i de wi kids
ye s ki d a y ai r ure sk ids ore l ids
the s li d are s lide ye r id ge o r ids
her e s lid es i m id a qui d e s quid
the p rides are squi fo r aid e to y i
there dibs a re bi d a d i b ore b ids
hence b ride s a bi de d o b ri we bide
we b rid ge de chi fo r ic h a b ridged

85

the ' chi c a c hid a s ide we c id
so d ich i s ids o r id d are c hides
she d i d a f idg e de f ri where f id
the gid e w e frid ge wi g li wil l uid
he glide s a g id d o g uides u g rid
his uides a g rid e to sh i de m e hi des
thi s a t ire hi d a s id he fro m e ir
we re i de l i re fo r ile were reil
ye ri le s a m ire so r i me we re im
re d iles are riem i f ire d a re m ir es
s he r ime s en ui re to s quire re quir ed
the qui re t is uire d as uires a s qu ire d
he quire s in ire s ure s hire de s ir es
erse hi re s a r ise wi s e ir are shire s
the re is e sire d an ir pe to p ie r
s o dan a s pire d i p ire wa r ipes
he sp ire s u s pei to s pire me p iers
me t ie r are tir e fo r i te de tires
yer ei t i t rie wi re i t are rites
we t rie s a t iers u rite wa t i ere d
f or ie ds a re trie d i f ire where weir s
me w ire s a s w ire to w eir in eirs
de w ire d e w e ird a wri ed an i des
the rice do c ire so d i re de rid e s
she fire s a d rie ye r ei the re id
he f ries a reif i ri fe w e re f eir
we fired an ire her e gire re fried
ye hire d a j a y ou jab be d a j ac
j as ore be j ack i f ire the re j ake s
jam e s a nc we j ape w i jas a saj
jan e s ap es a ja u so je de j er
so je d i j au n u je s are j ert
de j au ne w i jes erse je t a j ets
he je st s a j et ure j eu wi j ew
s he jews a j hu we j hu m a jib

me ji wa j ibs a ji m ere j i be s

j im s e w e re jib e so j imp e jil

jils el se w i j il t are j ird ore j it

here job s a j ob e to j ohn e j od

the j o b ore joe wi j oke s ur e jol

the johns a j ok e d u jo le d o joes

he jons ere j on e s ore joo wa joo m

s he joo s a j on ure jos ire j ot

j oy it s a j ots u jo w ere j ud

she joy s a jow i ju t o j ud ged

me j ugs are j u be w i jul i jum p

the ju les e jun o j u n e w e jup p

she j une s ere j upe re jur u j us

we j unks a j eld ure j us t ire jut

me j uts i ju te so f j eld are had j

t hei r a j ave h a j if uj ure haj

here n u j a sa j e je se be s aj

we jee ze me j ez a ma j o j a m

he jams a ju ice wi j am b el s arj

me m a rj o r ejm i sej m a s lo jd

t he p unj at ej e stij l u te j

the t ro j an s ak a kai wa k an

the kan d i k a were kra n a r ank

he r an ke d an ark u kars t ar e n ark

she n arks a rank s ers arked e re st ark

ka t eds ire nark e d aren t elch i keb

where t ak a n ark e wi ke d ure kel ch

de kelt c h a ske ne w i keltz u k emb

ye k emp t un e kes are ne k ore k ept

k en s ern o ke r while r ek ire k ern

he w o ke rse ner k a k er ve wi k est

his erk are ske t erse ke sh a ke t

red s eye d a k ye wi k hon d a s key

s he k eys a kh or i kho u m el se khud

thei r ik a re k icked a ki f or k ief

t hey ick a kie w it h ike to k ier

he k ilts a kike t ha t ilt s a n in ks

ki m ims a kilts i f ink e d are skin k

the k inks are ki ne f or ir k u k irk

he r irks are kir n er e rin k i k ish

she k its a ki s u k ist are s kit

he t icke d a n ick e to kite the tic ks

the k lim t i s ikes we sk ite wi kite s

the kli ne w i k ling e k ludge to k lot z

he knack s a k lutz u k n a pe wi k nav es

ye kna w i kni so kn i fe d are k nig ht

whence k nick a k nits i t in k erse s t inks

here k no w ere knol u kn ole wi k nop

hi s on k u k nots a knos p it s uck

t he ton k s i k nuc k if onks are k nur

where k oan a ko b a s of t are k ol

there kop i kol be wi k of t a k olm

de koo k ar e kou yu k ra t o kos

the k ors ch i k ra p else k rap p a kris

me k rug e kr app s a krup p u k wic

t he k urds are k woc i li ke d o l akh

we kyke t he li kes if uk a re m ike s

m ike like d a n uke where ku m iked up

lu ke n oke s a m inke to m oke de n ukes

the mac ke wa pi ke s o kip e we re s pike s

he p ike s u s pike me p oke we p iked

red okes i sp oke f or oke d a re p ok ed

he poke s an e ke we sp oke to p uke s

she spo kes a n u ke y er eke were puk

the pry kc do p rok e did a k e r ake d

the rak h a s hakes i h ask e wil l ikh

here si ke w ere sikh s a s ka wi sk ail

there s kal d a s nike re s ke de sk ein

he s kie d i sk ep o skie s ure s kim s

she ski mme d a s loke wi sk o to s ko m

88

he m okes a n ok e f or erk we re n oke s

me s mokes a s no ke t o s oke i s nack

his erks are s trike so s t erks u stro ke d

the stoke s is uk e t ha s t ro me st rikes

we s uke de sulke ye t o ke w a t rikes

t he w a ke y u troke w as akte do v lakt

me w ake s a w acke ye w ro ke so y ack

you r ac k ere ki b are k ibe weve b ike d

he b ikes a bik h ure b lok e were c akes

the b lokes are b ran ke so b rike de c ak

t he y oke the cl arke s u c ak e choke d

we coke s a sco ke y e cuke we re d ikes

d rake duke s a d yke f or eke s are fen ks

their eke d i f eke were f ike do f lake d

she f lakes an a ke w it h ike re f lock

where flo now uke s a f loc k i f luke d

thei r ock s a r u k if ike we h ike d

then ike d are g li ke w e grik e to hi k

the ha ke w ere hike d a huke fo r in k

here kin s in il k els e k in a re nik

he r inks are s k inn ed a ju ke wi ski n

ye r ink e d in ec k ure sin k ire sk ins

she s ink s a n eck s if ick are k ec k

there kli ti s ick ed o r ocks a r un k

here klu we k lick s i f ac k u k lunk

the k nock s a n ack s e r aw k a lack

t he l ank a re l ask e law k i slaw k

he w alks a swa lk a s aw k a l ekh

s he l awk s a n ick ere l ick s a s icks

hi s icke wa s aw k e l icke re slic k

here slicks a n icke d i f inks u li c k ed

their lin ks a slin k a s ink e d e s links

where l inke d a lir k i s linke d els e locks

yu s loc k a l ocke d ere lonk are luc k

the luk wa s ul k er se k lu wit h uks

89

he l uks erse lun k ire m ac k i n un k

hi s ark ed a l u s k i man k e mar ks

we m ark an ask to m en sk a m er k

ye mas k as ilks a re m i ne t he m ick

mick s ick e mil ke d in ock e r in k

he m ocks an irk ire m in k s u m irk

the krim are m ocke d a s mo wi s m ock

t hei r osk a r uc k a m osk u smoc ks

she m uck s in usk or e cks are sk um

ye m usk an ec ke where n ec k i s ic ked

he n eck s a n ick ed as ur k ar oic ked

nicks oi cks a snec k if oicke d are s nick

here snic k s in oic k e n oc ke w i nork

s he n ocks a nurk e re k urn an oin k

he r oin ks are ko for o k i s ack ed

you pack s a s p ac k i p ask ure pauk

where paw k i n eck e d a p eck a m icks

here peck s ure s pec o r eck e wi sp eck

then enk ore pecked wher erked ar iks

you pen k a perk s u p ick e d are pik

he p ick s a p in k ire p irk ors ank

the s pick e r ink ed ar ick u p in k ed

he spin k s a p lank i ple ck ore p lu cked

here pl an ks are p lin k a plon ks er ucks

these pl on k a p luck s ere po l ka a pork

where p ri ca n o uk ore pra we ve p ouk

the pou were p ran k s a p rick e r uck ed

she p ric ks a prink a s on k i s ulk

so p rok a r uck a pr onk u puc k

ye rok t he pun k i f unk e d are pul k

you punks a s pu n k e r ack we r ac k

her qui c k a r anks u ran k er e knar

the r anke were rau to r ec k o n ick ed

rick s ock e wi rau k a r in k u roc k

red s o ke w a r ok i rou to r ouk

me r uck s a n ucks if ac ke w a s ack

the s acks u re s alk u s ar k i s acked

he s acke d a ksa r ire s auk are s c hick

the sc h lock o do to s ch muck e s ch norr

so schme ck i s ook a sch too k ure sch took

we sc run k a s hank i sh irk s are schlo ck

me s hanks are shr ank ere sh riek i s ilk ed

ye s hrieks ure sh rink i n in ked e s ick

the s h rinks e s icks a shr un k i s il k

there sk un k ulk s o t o s lack en ulk

here skul ks an a ck s e s lank i s le ck

the s lik i s on ke d ans on k ure s lunk

ma s mac k ere slon k i mack s a m ok

the s mack ed i s irk a s mi t o s mirk

the s nark is ok erse s ne w a s neck

she socke d a s nor k i s nu wi s nuc k

here spanks a sok i f el k e d a spel k

the r el kes wi sp ra here sp rac k e panks

me p rac k i sp rink e p rui k ere spru ik

t here st ac k are t acks ere t al k is alk

her e s talk s else t alk s ur acks an alks

she tal ke d u st alked a stel k el se tic k

mine t acke d a tick s u stic k u p ick ed

there t icke d a stic ks i sti cke to st irk

here stric k i ne t ocks a s toc k ere st reck

he s tock ed a streek a s oak ·i s uck ed

de stroa we re st r oak i stu wi t uck

he s ucks a s tuck u p un c k erse t ucks

de suk are suc ke d a s ulke d i n un ck

red s uc ke we sun ck i f an k a swak

ye s wank s a w i to w ings ere s win k

youve w inke d a n ick a t asks u s wan k

the tchick are t han ke d a s eek i t hee k

the y an ke we t heik e thin k a t h wack

we t hun k erse t ok o r on k ire s tonk

91

 the ton ks i s ank e r acke wi t o sk

 he t rack s a n o sk or eks a t ran ks

 ye t re k i n ick ed ere ku we t rink

 s he trick s a t u k erse t unk i f un k

 me t wic k are t win k or u k e ku n

here v ic k i n u k ere vic ks o v ic t

 the ir ac k i s aul k u wa t o w ack

 here s wa n o s wacke d i f isk are w ark

 he r isks are w aulk erse w hack ed a w hisk

 the w hi were w is k in iske d a w recks

 so w recke d are wrink i f an ks a re y eck

 she yanked a y i ke w i yock o r oke s

 t he y o ke we yonk as or ks a yu ck

so zac k s its er k are y ork s in arks

he zonk s u z er k if ar ke d are z ouk

 the y as k a s ask i bac k els e b ank

 her aske d ere sk a wi ba d id a sks

 s he b acked an an ke d or a b a b anks

 the bar k er arked a k na b u b ask

 he bask s a d isk a s erbs a re b elk

 w her er b it s ic k id ilk a re be lks

 t here b er k is er b a k erbs u bic k

so b ilk o b lank s a b irk ure bis k

here b lanke d ou t en k i f ink s a bleck

 me b link s a b len k u b lick ere bli k

 le n o cke d a b locke for olk a re b lok

 she bl ocked an on k els e b olk are bo n k

 he r onked ure k n o b ire b onk s in ouk

 me k nob s in onks a s ic ks ecked ok e d

 the b ork a re bou k els e brank s o b reck

de b ricks are br ink s a t ac k erse bricked

 yer ri cked it s uc k ire b rack i n ul k

 so b uck a bro ke w i brak u b ruc k

 r eds ur k e re b ulk i kru wa b un ked

 the bur ke w a s us k a s aw k are busk

he b us k s an alk e c asks are c auk

me caw k it s au ks if an ks ire l ak

she ch al ke d a kal u c ha w e c hank

sals ecke d a c hark i c heck e d i n ick

so c he c hecks in a n eck ure chi ck

he chin k ed a n in ke fo r ock i chir ck

there c hocks a ro o k i f ork are c hoo k

we ch or k i n ow k ere c ho to c hunks

the c how k a r ake f or an ke re c lacks

ye c lake de clan k a l ank i l a nks

you r ank ar e ck if erck a c lank s

bu t er k a r ei k if euk ore c leck

he c lerk e d a c leik i clerc k o r ink

we l icked it s o ke fo r ic ke wa cle uk

so c links ar ock e whe n ock e d i c lock

the c loke wa s on k i f olk are clon k

the y on ke me co ck u cl on wa c olk

though c ock s in onked a n o rk s i c onk

her or ke d are conk s u c ro d o croc k

the cric k is on k it s uck are c ronk e d

he cron ks a n us k if au ke w ere c ruck

ye r onk s u c uck as ecke d a re c usk

m y e cke wil l ack s a d auke wi d awk

you deck s u p it s are d hak e r aw k

here khad a r aw ked el se d ick s a d ink

the dic k en s aw ks an ir k i d haw k

ken s ir k i d in ks u d irk en isks

she d isks an ocke d if an k is e k

he d ock ed a d ork u dow k ire d rack

where d ran k a d raw k e drec k a d rek

she d rinks a n ook ure d rook ire d row k

t heir unk a dru nk s a n ucke re d uc ked

he dunke d a d urk a n e lk are d w ork

re ds of f are f alk an er k ore f eck ed

me f inks a re f erk or ec ke wi f isk

93

the fir k i n an k s an ak ure f la k

he fl an ks a r anke d ere l asks ar as k

the flas k ick s in ck u fli c a r isked

we f lick a fl in c k els e flocke d e flisk

so l ic ks a n ock to l ock e me f lunks

so flo cked a r un k an olked i f ork ed

red o lk s in ank ire f olk s ure fo r ked

fran k is ks a frack e r is k e w a freck

he f rank ed ur eck a s uck e t he f rink

she f ris ks an iske de f ro cke d e f rick

the frosk e ric ke w he r uck e d are fcuk

me f unk o r us k is isk a re f uck ed

here fus k a gaw k els e geck i s ee k

the geek u g lic ke w e r ick e we k is

ye r isk erse glis k it s oak a r ow k

you glo ak e gon k an ur k e r ow ks

the g or k i gro k a g ow k ure g rock

he hack s a s h ac k its arke wa s ark ed

she h arks an as k u h ask a r ow ked

h er eu ks a hec k or e uk s ire heuk

de hick s ure hock s a s un ke wi s hocks

hi s ock e d a sho cke d if onk ed a honks

we shon k an ock e fo r onk e we h on k

huc k un k s a sh ucks are huk u hun

he hu n ks an irk i f ir ks a re a cked

jac k erk s a j ak o r ink s ire jauk

so jack s o n au ks a jerked i ja c ke d

he j erk s a jin k an d e rk are joc k

we j in k a n ak ke to ka kke the trek k

the lak ke w ere la c o y ckkc re t e kk

ye t ekke me k ke so l an a re y akk

c ale l ace d a m a l u l ams in alm

t he n o l and alm s a l ance de n al

hence s al is al s else s la w i l as

t he st a l in alt s a l ast ire sa lt

94

 he l ast s a sla t o r au l u s a lts

 s he s lat s a lau wi l eu to l a ur

 me leg h ar e leh r i le ig e l eigh

 so l ils are l ei we l ilt ure l im bed

 she l imb s a n ile so m ile ti s iled

 fo r ile s are li m u m il ere s mil

 the s lime d a li me we s mile t o l in

 sher im b i l im u sli me wa s mi led

 dee l ime s e smi les are l in d el s ils

 here n ils are lin gs e rs ils e wi lls il st

 the lint ire l isle were l is t e n il ts

 you s ilt a s lit ere li sts are s lit s

 yer oa ls e s ilts e lo w ere l ob es

 me l oa ti lo be s o b loe where l och

 de b ole do l och s ire l od h ure c hol

 the h old i lohse to l o n a l onc h

 the n ol d er e l on d on oe l or ol

 ma l one wi n oe l are lo p u p o l

 he l op s a s lo p i s p lo w a poled

 t he l ope ma p ole so l ope s er in

 she p oles a s lo pe wi l oq u l op ed

 we l ose the so le whe n o l t a sloe s

 ye s oles are los t ere s tol i s oul

 you r ole wi l ot e t ol are s lot

 lou s lots a l o te we l ots a lou d

 he r els are t ols e s lo u wa l o ugh

 yer ou s a s lough el se l ounge di l ous

 the lou se w a lo u p i f its are poul

 you r olt er se m ole wi d ol e r oles

 he m ole s a p lou whe n old a mo ld

 hi s olds a re m olt e re d ol ire so ld

 where p lot a l o d u p lo to p l ods

 me p lot s a rol e we l ore wi sk ol

 re d ole s are s lo v as ol t are t olt

 t he w ho re v olts an aw l e w ho led

95

part seven

so y aw l a n a wls er e w al e l aw

ye b hi l are b lo w i b loc s ire b lot

the bl ot s u b ol t a b lot e me bo al

yu b olts a b old i c loa wa d ol b

he c lod s u loa so c loak s o c lo am

the cole s ere l oa k ar o l t an o led

th ey ol t s a d ole to lo de d e c olp

she c olts i d ole s i f ol d are do lt

re d old s ure to ld a l o d e l ode s

the g lobe ti s o lb i f old e gl o d

de fo l u g lode fo r o le d are g lost

we g lo se m e hols els e ho le d e l os

the hol b ein o les a ho lme w here h olk

ye r ol me s is ol an ol s erse h olp

he h olt s a l ot h u sho l ire s holt

the hols t is oh ls i f el and o lsts

he j olt s a ke ls e he ls ore m arl ed

the hohl a l ar m a l arme d u m erl

we m ur l where n arl el s or l a l arn s

t heir arls ar e lor hence ro l arent i r l

t he p irl u qua rl ere p url s ure s car l

car ls uerl is ir l u sh ir l e s lurp

me s pa r l i q uerl e sch orl a sn ar l

t hey irl a ri l er irls a re squ i r l

me lir a swi rls i f ar le d are t hirl

ye tir l i t wir le d a v ar l u w harl

de w hir ls ar irle d a w hor l in arl

the whur l is a l i f ir le w ere l ar

hi s o ral url s a y ar l ire b erl

s he bir l s an urle d u bu i l i c h arl

the l arc h is irle d a c ir l else c hirl

me chur l it s ir ls ere l urc h ar e rls

we c ur l a l u fo r ur le d a c hur led

ye d ar l in ar d i d irl ar e lards

you far l a f ur l er se l arf u f urls

he f ur le d a g irl u le r i g n arl

their arl a re g irl s i g ur l ore re l

we hurl s a n erl ere her l a re j arl

erse h ur in ar le d a k narl i k nurl

so k ar l ure l ar k i ns all ure k erl

t he l all a lill s if ol l are l l oy d

his oll s a n ull e ll oyds u l ul l

we l oll a lull s ire m ai lle w i mall

her all s a r ail le we m all s or e lls

here s mal l s i m i wa m ill s ure m ell

molls ell s ure m il le d a nd oll s e rs ill

m ell elle d ar ille fo r al led a m ull

nell s ol le wi n i ll er e nol l a n ull

ye r ul le t he n el l if ull i n o lls

though nol le w ill ell it s il ls a nul ls

where i p al l oll ed an ells a p al l ed

hence pol l i p el l u p olls a p illed

here p olle d a p roll i prill ar ull

ye p roll s i p ulle d or e ll u que ll

de se q uel l s el l a q uil l an ol l

the quo e q uol l u ral l ere ril l

ye r oll e d are olls i r ol l o r ull

the rol l s i s c ro d e s alle wi sc roll

their sc roll s an ol le d o sc ul l ure c ul ls

mine s cul l ed a r oll ed a nd elled ire s ells

ye s hall ure shel led i f ill ed are hel led

though s h ell s a sh ill e she d o s ills

she s kills e rol l a sk oll s i s kull

me s ku we sk ill u kul l i k il ls

we s me ll a s nell a s ell e spel l

the s pall i s ull e d u s pill i s qu all

her e s pe w i s pill a qua t o quall s

de s quil l i st alle d i f ills ar oll ed

the s tall e st ro f or ol l else st ill ed

so sul l a st rolls e re st ull ar ull s

she s will s a w ills i f il le d are ta ll

t he se t el l it s ail le so tells ure t hill

t he st el l i t ail le we re t hall us all

w here t hr al ls e n ill ye t h rill a till

youre til led u p oll a s ills a re t ol le d

here t ri wi t ril l el se t rolls are trull

though t uille s er uill er se t u ill a m ull

t he t ul l a t uille hence v al l ore ve ll

red s ill e de v il le w here w all is alls

we t wil l a w alls er el le t he w ells

t her e s wel ls an alle f or a l l ar ell

t he w eill i s el l and eil ls are wille d

the wol l e n ell e s are y el le d or ell

he b all s u p ol l ere y il l arent e lls

me bal l ad e ll s u b a lle so b ell

the b ell s an oul l i b elle ma b ill

the bol l i s oul le where b ril l ore b ull

me boul le we b ra il le re c alls a scal l

the cel l o c ell s ure ch al l ire c hill

she c ill a chi l le hence col l in e lle d

my oul le wa c oll a n ail le re c r ull

ye cul l e n al le wi c ulls er c ul led

the del l i d al le we d ell s a d ill

the d ill s a d rill u d ri m a ril ls

me d rol l or e lle d a d ul l u d well

yu d we lled u p ills i f ell s a re f all

hi s ell ed a r ail l as uel le wi f e ll

we f ail le be fel l ed il ls are f elle d

ye fille d a f ri e fri l le d are fu ell

the full e r ill e d a g al l o g alled

his ul le we r aul le t o gel l a g aull

the de g aul le g elle d an aul l e g ri ll

the gil l a r oll e re g ril le d are gill s

m y o lls are gri l le s o g ryl le w i gull

the h a ll is olle d ure g ulle d a he ll

 the hills a r ol l e w it h alls a ho ll
 t heir ull a n i wi h ul l o n il ls
 hi s ull s a r oll i f ul l e d a jells
 he h ulls erse je lle d a t all e to j ill
 kel l s ull s an el se f or all a jo ll
 h er all s e k el ls i f ell i s al l e d
 were sk el l ure k il l ire k nel l in o lls
 yu k nelle d a k nol l e ma m e koll
 you krill l a n am m u n it s a m amm
 where m an is a um ure s ma le m ans
 ye m au the na m e r oa m are p imm
 t here m ao ti s am s a s im m u r im
 the mi ro p rams a nd im me to s mir
 hence sa m am me d in a m a s i s cam
 macs am s a sla m o r am p i s ma l m
 mal s al m ere tam p o w ham a y am
 hen ce ma d i m ay as a m are ba m
 she m ay s i s may i f ame d a re m ab
 the bla m are m ace tha ca me t o c amp
 red s am pe wi b lam e f or amp e r amp ed
 he bla me d a c amp s e c lam s u c lamps
 the clam pe d are mi d as im i c ra m pe d
 he d im s a m ids e re d ime s e m ims
 here m al f i g a m erse m a g u g ames
 mag s ame s are ha m ere ma h u h am m
 there jam e s a ka m el se m ak er se m al
 thence la m is a mbe d i f am b e r am ps
 where l am s ire m a s ure ma t he l amb
 we slam s i l am be d o r am de m ahl
 ye r am be d are a lms u m al m a n em
 the m al t is al m ure m ast e rs al t
 hence m alt s a sma t i m as ts e m at
 mat s a me n em s u re m e m i t am
 the n e m o m ens e de m ent a me ph
 ye me rce wi c rèm e so m erde re m erd

101

me m eu we m euse so m eu te w a s ew l

we m ewl s a m ids t u m eu wa m il

the m ig h e m ight a mil ne t o l im

here m il ne w a mild a s i m il t on

your im es a m ine to m in ce re m ind

where m ime s a m in i min g ure m int

through ime d a re m i wi m irt h e th rim

we d e m ise mis t i f it s u m its

the s ti m ure m is i m i te to s mit

youre sti m a t im e me mit es e r im ed

hence t ime s ure s mi to m e rk e re m oc

here s mite s a n o me so m oe t here s mog

ma m oine were m ol el se l om are m om

the s ome we m o t o m on te de m op

there po m is om p i f op s ire mop p ed

his om pe wa s u p a p ome here mope s

red s ope wa m ope d a m oste re st om

t hei r ope d a re m o so mot if s oped

shoul d ou m e m ote tis u m i t o me s

there t ome re m o tes a mo u d o s mote s

we s mot e ye r urms ire m u wi m um

mum s u r a m use me murm e r us e d

though m u se be m us ed an u st i m ust

where m usts a n ur m el s e t ums ure st um

t here um m e s mu we re st um m are s mut

the sm ut s are n a y ed i n a whence n and

n an ce n as are na y s ure sa n or e nc

so y an i s an ce ma n eic e to n er

the n e c a re ce n ire n ie ce wi n eur

we n eu me w i n ice f or ince wa l in

the c ine we n idge to l i ne t he n ile

nei ls ine s a m ie n o m in us in e d

there l ine s u m ine re m ien a n im

whence n imb u s in e me n ine fo r o an

no n ob s i n oa we r ine er se m in es

102

ye s nob s a no de t o d o ne t he bon

he n ode s ure no m ire n o me w i m on

there n once we n one so n or n a n on

me n o pe w a pon e were n ose de n otes

he nose d one ton e fo r on e d a s tone d

re d on es i st one we t o ne d e n oug h

nan s ou n it s on a s o uns are no uns

her o urn ere non e nou we re n our

t ha ts ern is a n i f aw n ar e p ern

he p la n s ere l a n o p li n ire p irn

she p raw ns el se p rin are pu n a n up

he run s ur e pun s erse s pu n aren t urn

the re q uin a r ein i f ur ne d are ro ans

t here r oa d o r un a rei d id u rns

we re ine d i n uns a s in se wa r ein

there run s ure r inse d a s aw n i s wan

hence w an s awn s on ers e swa n s u s c ran

w her een a re n arcs e r ew n awned scree n

there n ew s e w ens are sh in ne d e s ewn

the hun s ire s pa wn ed a sh un s i s horn

thr ough m a ne t en s a t en u s ent

you nes t a t en s ure st e n or ent h

me nets are stens i nests u then

there n eth e r in t are hen t ire t in

the n it ins t in erse t in s ure n its

hi s in ts a s nit i sn ite wi t h or ns

so n o rths u r ai n or or ne w i t urn

the run t a t aine d ere tra in e d ar urn t

he t u rn s an ain e fo r unts ire t run

r eds u rt is in t h a s nu were s nurt

there tu n a re t hin ure nu t else s unt

hence nut s a t win n ed i s tu n on u ns

here w in t er u n are n u va n av

he v an s a n av i w in ne t o w en

the s van a re wa in e ne w is e wn

103

ye r ew o hew n a y aw n u b ans

my ai n a re na i f aw n o wes ens

be n s an are ne b i s ne w i sne b

there b urns is ur ne d a b raw n o r an c

hi s in c a re c an erse na c a c in

me n ic s it s ar n a s oon are cra n

t he n ar c is o oned if oo ne w ere car n

he r oo ne d a c roo n i c ur n in e nd

de n en d s a d rai n i f ai n un aun

the fa n on an s a s en d ure f aun

h is ern are ne w i f awn e d a r en

t here ner f ern s in a f re n u f ern

he r eign s are fu n if or ns a gaw n

glen s or n is aw n a g nawn i fe i gned

he h orn s a ho n else n o h are j in

the h or ne t is il n u k il n as u hn

mine l ink s a k iln s if oa n e l ien

the kuh n i s o un a s oane d are slo an

the n ile were l oan e d a m au n ire m oan

whence m ou n a m u n i nu to n um

n an n its an un n ure pan ne the n un n

hence p an n a p en n in un ne so p la n

there pry nne ti s an n s u p unne d i p in

the qu in n is en n ere r ann erse s can ne d

there sen n a sh an n on inne d e sk in ned

tho ugh shin ne d a sh un ne we s onne to s tun

there s wan n i s un ne d as anne d are ten n

he tan ne d a t hen ne ye ti nne o t hin ned

you ton nes ar un n a t wi nne d else v ann

the venn a v anne d e w hen ne w i d an n

here w on ne me w yn ne to n ye t he b ann

there ben n u b an ne re b on ne w e b inned

though an nes a re c ann if on ne were can ne d

whence c anne s a chin ne d i c onne d e din ned

the don ne t is en n u d un n erse f an n

104

he fanne d a frenne so go n ne the g unn

red s in n i t in ne me hen ne r e ja nns

jan n in ns a h ey n ne to t he jen n er

here j in n i ken ne w i ni the m an n

there m ann s i s oak e re l in n u m inn

t hough oaks a n o ap o r o as t ar oats

where tao wa s o at h as oa ve w er o ach

we ve po a ch an oa d i f oam i re q uoad

th ere r oa wa r o ach i ro a d u r oam

he r o am s er oa s ure r oas t a s oaks

where soak a s ao f or oa ke w a s o am

t heir o a me w ere so ame s i soa to s oaps

t hey oap e d a s oars it s o are re s oare d

the se stoa w ere toa d e t hroa so st oat

thei r oads are thr oa t ire t oa wi t oad

we t oa s an oaz ure to as t ar e wo a d

thi s o aze wa bl oat e to aze re b oar

hence b oas t a b oat s i b roach a ch oak

where co ach a c oa de to c oak e co al

here c oal s an oars e so co ar se w ere co ast

you c o ast s a c roa do c oat s ure coat h

her oab i s o and u cro ak i do a b

me do a we re d oan d ere doa t a fl oat

she flo ats a foa l ire l oa f e ds o am

t here l oa wa lo a f a foa m u g loam

where g loa we g loa t i goa to g o ad s

erse me g oat s o ane me g oa f are g oar

where goat s a g r oa h ere g r oan and oar ds

though oar d are hoa d o h oa r are g r oats

here ho a rds a n are we ho a r o r oas t

the h oar se w er e hoa to h oas t a jo an

he r o ads are loa ye l oa d o res oa d

she l oads a n o am i l oa m in oath ed

t heir oi we m o a we co i wi l oat he s

ye r oi c i s o il ere loi wa m o at

my oil s u re soi ye s oi were s o iled

ye r oi me w e r oil a poi his p oin d

he r o in t a p oin t u p oi se wi quo

she p o is ed a quo i wit h o in e qu oin

there quo it s are roi ye l oi we r oil

where l oir erse r o ile d a s oi to s oi led

t he spo i we s poi l an oi t u t oil ed

me t oi l oit els e no w o ile we t oils

ma t oi le we r oi se so t oi se t heir oiced

the t roi l us oi d a t roi we re v oice d

he r oid s a void s u re v oi wi yo ick s

s he b oil s else v oi re d oi w here b o ist

the v oil e we y oi fo r o ick are b roid

t here b roi ls im o ice we b oi to c hoil

de c hoi we b r oile d u c oi wa c hoi r

ma c ho ic e wer oir if oi f e n oir s

his oig n a re c oif i f oil e mi ne c oign

he coil ed an oin s i c oi ne w i c oir

s he c oin s a c oit us oi te d a c oits

we coi te m e do i t els e d roi do d roil

he f oile d a roi t i f ois t ar e dro it

me f oist s o re f oi to g roi so f o in

s he g ro ins a n o ick u hoi wi ho ick

he r oist s ure hoi se w e hoi sts ire ho it

here hoit s i joi fo r oin e d are jo in ed

hence join ts is oin t i f ois t ar oists

she joist s a n o in e me koi w ith oi d

the k oi ne w er e loi y e n oi re l oid

me l o in s ar oi n i m oi to n oil

we m oile de m oi l a m ois t en o in

t he re n oi r oo hs an oo h a n oint

their oo he d a hoo yu roi n i n oo m

whence noi se t is oon i s hoo w ith oon s

red s oop s a re m oo ye n oo wi so o n

me s o o t oo t oo fo r oot ar e s oop

hi s ooze we sp oo no p ooc h u po od

 t heir o o f a p oof is ooze d are s poof

 me po o we re p oo k i spoo k i n ooks

 thou spo oke d a p oo n or oo p e poon

 where p oons a sno op e s noo wa s no ops

 his oope d a re poo p e p oope d in o or

 she p oots else p oo r oot s err ed ire r oop

 thence sto o we r oove ye p oo to st oops

 tho p roo t are t roo p ure r oo wi r oof

 there r oodge wa r oofe d i n ook u ro ok

 where r o ok ed ere roo m u m oor in oo med

 hence mo or s u room s in oom th i s moor

 their oo se ti s or t ere roose we ro omth

 she r oosts e rse ro on ire roo ts in o orts

 the scroo ge t is oos h e st oo r ore sch oon

 these scoo sh a scroo p i s hmoo to m oosh

 here ho od s a s hoo d u school l e s choon

 where hoot s a sh oo t u sk oo sh in ooch

 the ir oot h a s loo s h i s mooch on ood

 were moots a s moo t a s oot h s ire s moot hed

 though toon s o re n ooz are snoo d ure s no ot

 he s nooks an oo the so s no oze d are s oo k

 t hough s oo l are s oor its oo ge wi s oot

 here soot he de s poo f e st ooge wit ook

 their ool i s oon ed a s took erse s tro ol

 there swoo t is oo p if oon t are st root h

 she s woo ned a swoo p i t ook it s ooth s

 the too ke w a t oots ure t roo t o t oot hed

 w here troop a v oo ye w hoo so v oom

 his oo w are voo r el w oo wi r ooved

 she h oo f s a w ho so w hoo p ar ood

 the w oo d is oore if ooe d a re w oos

 the w ool f ir oolf e wool fe w i s wooed

 though ool s ure wool d a w oo n e w oot

thence wroo t a y oof i yo u p are z oos

the zoo t is o oz e z ook s u z oom

she z ooms a n oo ms a s oo n i z oon

hi s o oph a re n ooz ire loo t o z ooph

he b loos an oo b and oob s are l oo b

he r oom e d are blo o so b loom a b lood

s he b loods a b loop o r ood h ere sb loo d

the bo o we b loot h el se b oos a so ob

t hen ooh s o boo b e b ooe d a b oodh

he b ooh s e bo ok s u s koo de sk oob

his oo ke w e bo ok ed i t ool s an o ong

the bo o ne w e b ool s is oose ma b oo m

s he b oons an oos t i b oo se w ere boon g

he r oost s are boot s u b oos t in o oched

we b oost s ure b roo to c hoo t he boot h

the b rook e ye b ro och a d roo we b rood

his ooke d are d roo b u b roo l i b room

me broo se w e c hoo k ere cloo w i ch oom

were clooc h a c loo p ire c loo re c loot

ma coo no w ool ed a c ooe d i c oof

she coo s i c oo le f or o olt h are co ok

h ere c ooke d a r oom b u s coo wi cool

re ds oom b s e c oolth if ool e co coo n

hen ce ned s a c oom b i c oo p u p oots

the c oots a r oove d a s coo t u s cro od

here c rook ed its oo d i d oo wa c rool

yo u croo ve m e d hoo so d oor e d ho on

ye roo d are d oo b o re d ook ire d ool

w here l oo we r oom e d o l ood a d oom

me m oo d is oor d an oo m e l o ord

ye r oo rd s u m oods er oo le w e d rool

my oor s i re f loo wi d ro ped a l oof

t he f oo l in oo d ire f loo wi f lood

he f loo s a f oo fo r ood s ure f look

reds o or er e flo ore d if oor is o od

so f loo se w er foo d an oore d i f oot

she f oot s it s oo s i g hoo to g hoor

so g loo re g lo od i g oo m a g loo p

ma g oods u goo f o r ood ge was ood

her e g ood ge ye r oof no w oo g i goo f

ye goo g a g ool else goo ge t he go ok

his o ose d are goo p i g oose wi g oor

the groo f are g roo m u g roo for oov

de groo p is erse me g roo se w a g root

t heir oo h a g roo v its oose we ho och

he hoo s an ootc h ire s oo wi hoot ched

so m a hoo d s o ome w il l oo f ire hoog

the ho ok e wa hoo f e d i s hook in oop h

he hooks a h oo l u h oo me to h oon

the hoo p is oo pe d a p ho o do p ooh

here p ooh s o h oose me h oos h ere h oot

there hoove s u re j ook a h ooze b e k loof

these de k oo n oo k u k noo p i n ook

he n ook s a k oo so r oo t he koo ns

we s nook s a n oo k i k roo wi r ook

he r ool a re l oo s o kroon i s oon

t he l oo k is ooc h u l oo ch i k ool

we l ook s a l oo m e re m oo de mo ol

the lo oke d a l oo me ye s loo to l oons

red s oo p are l oom s ure s loom ire sno ol

here s oone d ere l oo p else p oo wi s pool

s he l oop s ire poo l ure s loo p i p o ol

there s poo wa l oo p a s loop s u p ools

ye l oose me s poo l s un oot s o lo ot

we l oo wi t oo l s if oone d a rent oots

you sto o l or oole so m oo g an oon

the m o or e ti s oons as or fe w a moo n

where m oo p a m o o se be fo re de m oot

the noo n s a t oom i f roe to n oose d

their or ke ti r o fe fo r a n or p en

where k ore de p ro do ro ke w ere p or

w hence r ot s a t ro w i st or u t ors

 his ors t a r e sorts i st ro w i s orts

 here p ores a n or pe w e p o re to r op

 de r ope s u s pore so p ro se w a p ros

 we p ore d a s por i rope d e spo r es

 thei r or n u s pore d i p or n e p ron

 the p ort s o t or p re t ro p else p rot

 he p rots a st ro w a s tro ps in or t

 ye s trop u s por ts i p or te to t rope s

 she t ros do t ro pe w e p rore d o sp ort

 though or e wa r ob e er b ore wi p or te s

 where b ore s a ro bes e bro se w e rom p

 she r obe d a n orn ire s orb e y e r on

mine nor a b o re d i ron s ure s n ore d

ma r on de w a s cor ch a sh ore to s nor

here s ho a h or se w ere s more re rom es

 t he st or k is orsk a s or ks are t orsk

 there st o rks an o r ke m e stro de s t roam

 ma st ro be d a re st ro m ire ro wi st romb

 hen ce r ome t i s tro me ye s tro n g ure rons

 the r o no st rop he re th ro ma r ones

 the d o rs a th r one d e th roe do th rong

 dee ro ne t i r onge d are t hr ow n in orch

 where t orc ere t or c h a n orc he re c hort

 were t or ch a t or n ire t ron ere nort

 t he t rot s ure r ont else ro t ire to rt

ma t rot e rs ot ure h o re d e t hrot

where rods a tro d a d or t u t h rot h

he w ho re d a hore wi t hro t e t roy

me w hor t ar e w or n a y ore to r oy

reds o rd s ore r ow n if or d is or g

 ma yo r an o rg s i b l ore re b orc h

 w here b org e bor d are g or b a b rog

 hence bro wa b ron s u b or n in or b

 so n or b s e r oc he the b rock a b rod

he c hord s a c lo re f or orc a re c or

though or be re c lore s a ro c ire s c or

t heir er se de cor s a c orb e re c ords

t he c ore wa c orse so s co we s core d

here s co re t is cro se f or or m i c ored

mine s core s o cor m a c orn u s corn

her orp s i c orne d e s corn e d a spor

she p ro s a c orps as orved a c rop s

were s cor p an orp se f or or ve wi c roc

here corp se ti s of t ire cor ve w a cr ofts

hence oke ti c ro ke s o c rome w ere c rom b

whence crop s ure rop pe w e r ore ti c rop p ed

there c rore wa s or se hen ce rone d e n orse d

ye d orse re r one d erse d ro wi d ron ed

so n e d o rne d orf ure dr oyl a d roy t

the r olf s are f ro t ha f lor i n or ced

y our or fs a cor f ire c or f e to f roc

t he f ord ere for ce d erse f or t u f rot

me fros t in o rce do f or ge t he fro gs

the from m i s ore we f ro re to f ront

the fron de re f ror e ye l o re m a g orn

we g orce t he go re so g or se d i g ort

his o rge de g org e d as ors e be g rot

she g ro wi t ro g o g royn e the t rog gs

t heir ord s ure gro g it or de re g ros

we sorg s o roy n ed u hor d a re d roh

re d or des e r oyne u jo r are gro y nes

he hor de s ire r oy n ure hor de t o j orn

de ho re we k ro w he n o re wi r om

dee l orn a kr o ne de m ore ye r oms

she n orm s an orns if or ne m a m orns

here m or ne re m orse do t or m e n ors

hence m or t ar e nore ye r o ne to n orsk

he r o es and ore s or ors e where s nor k

ther e sor e i s ore d a rose re t or